Monoprinting

Monoprinting

JACKIE NEWELL
&
DEE WHITTINGTON

A & C BLACK ▪ LONDON

With thanks to Keith Newell and Robert Martin
for their patience and support throughout
the writing of this book.

FRONTISPIECE: Dee Whittington, *A Night on the Tiles*, 2004, 20 × 15 cm (8 × 6 in.).

First published in Great Britain in 2006
A & C Black Publishers Limited
36 Soho Square
London W1D 3QY
www.acblack.com

Reprinted 2008 (twice), 2010

ISBN: 978-07136-6746-2
Copyright © 2006 Jackie Newell &
Dee Whittington

Jackie Newell & Dee Whittington have asserted
their rights under the Copyright, Design and
Patents Act, 1988, to be identified as the authors
of this work.

Typeset in 10.5 on 12.5 Minion
Book design: Susan McIntyre
Cover design: Sutchinda Rangsi Thompson
Copyeditor: Rebecca Harman
Proofreading: Sophie Page
Project manager: Susan Kelly

This book is produced using paper that is made
from wood grown in managed,
sustainable forests. It is natural, renewable and
recyclable. The logging
and manufacturing processes conform to the
environmental regulations
of the country of origin.

Printed and bound in China

CONTENTS

Acknowledgements

We would like to thank the following for the use of either their work or expertise, and often both:

Alan Cox, Sky Editions, London
Alan Cristea, The Alan Cristea Gallery, London
Anne Desmet
Anne Gilman
Brian Beames
British Museum, London
Caterham School
Cy Ford
Erin Salizar, Alexander Bonin Gallery, New York
Falkiners Fine Papers
Frankie Rossi, Purdy Hicks Gallery, London
Gordon McEachran
HMP Downview
HMP Wandsworth
Howard Jeffs
Intaglio Printmaker, London
Jane Stobart
John Phillips, London Print Studio
John Purcell Paper
Kate Ganz
Linda Lambert
Matthew Meadows
Michelle Tiernan
Sam Gurney
Simon Fitzgerald
Students from Orpington College
Students from the Camberwell College of Arts
Susan Kelly
Susan McIntyre
Susan Rostow, Rostow & Jung
Vijay & Kathy Kumar
Zelda Cheatle Gallery

INTRODUCTION

Monoprinting is the production of a unique print, currently enjoying a successful period with many artists utilising the opportunities offered by this remarkable medium. It would appear by its current popularity to have been accepted as a respectable member of the printmaking family, as well as retaining its individual identity.

There are a number of different types of monoprint, the most popular being the monotype, also known as the painterly print (see Chapter 2). This book introduces all the various options available to the printmaker who desires to make unique prints.

Many artists have produced monoprints through the ages. The legendary artist William Blake, born in 1757, is considered by many to be the father figure of printmakers. He was traditionally educated as an engraver, but extended the boundaries of printmaking by adding watercolour, gouache, varnish, pen and ink and sometimes gold to transform otherwise conventional prints into monoprints.

The famous 19th century artist Edgar Degas successfully used the monotype technique and was a prime example of an artist who explored the potential of this process. (In the monotype technique, the artist uses a smooth plate, to which ink is freely applied and later removed by the use of different tools and materials.) Degas discovered that it gave him more freedom and offered greater spontaneity for improvisation. He would paint or roll litho ink onto a glass surface and then expose areas of the plate by wiping away surplus ink to create atmospheric images. He chose to work this way deliberately because the results were considerably at variance to those in painting. Degas usually printed two impressions of each monotype subject, one strong, the other faint. He would keep the first impression untouched; the second would be a 'ghost' (almost a smudge) on the glass, left from the first print, the residue from which he would then rework with pastel or gouache to produce another unique image.

The soft, smudgy, velvety quality of the monotype is both unique and sensuous, differing from the results achieved with original prints or conventional painting. *Le Sommeil*

▶ Degas, *Le Sommeil*, (*Sleep*), 1883 – 85, 28 × 38 cm (11 × 15 in.). The first 'untouched' impression.

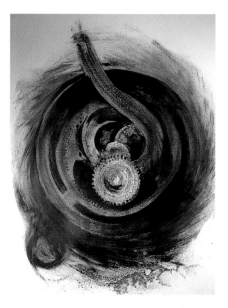

▲ John Jacopelle, *Red Sky*, 2000, 30 × 40 cm (12 × 16 in.).

▶ Jackie Newell, *Reinventing the Wheel*, 1995, 110 × 150 cm (44 × 60 in.).

shows the inventiveness of Degas' method of handling the ink. The pattern of the light and shadow and the distortions in the figure turn this into a dramatic image.

A contemporary example of the conventional monotype is Maggi Hambling's *Jemma Relection*. The bold, gestural marks provide evidence of a study made from a life model. In this print the artist is working within the tradition established by Degas.

Monotypes offer a wonderful and expressive opportunity for painters to explore their ideas and styles through colour and mark making. This is evident in John Jacopelle's *Red Sky*, where the artist applied paint in a loose, almost Fauvist style using oil-based ink on Plexiglass™, which was a two run print.

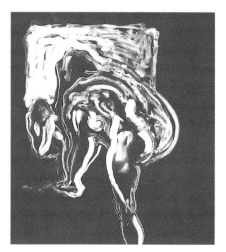

Some workshops and institutions offer facilities that can print large pieces of work. Such was the case in Jackie Newell's *Reinventing the Wheel*, where the artist chose to work on a sheet of Formica™, to accommodate an A0 sheet of printing paper (size 110 x 150 cm or 44 x 60 in.). This image used subtle coloured inks mixed with copious amounts of transparent base, which were deliberately chosen to create an

◀ Maggi Hambling, *Jemma Reflection*, 1991, 60 × 45 cm (24 × 18 in.).

effect of machinery in motion. This was then printed on a press designed solely to print monoprints.

More complex techniques involved in monoprinting are evident in the collotype *Cell Portrait Series* by Zara Matthews. This shows an adaptation of lithography using multiple prints derived from photographic negatives, where photosensitised gelatine is applied to a plate and then exposed to a negative. After careful processing the resulting plate is inked and printed on paper. Although this method could be used to make an edition, the artist intended this print to be a monoprint and therefore destroyed the plate after printing.

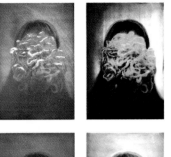
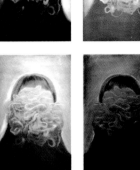

▲ Zara Matthews, *Cell Portrait Series*, 1998, image size 23 × 15 cm (9 × 6 in.).

Printmaking is fundamentally a reprographic process designed to make art more affordable. However, the monoprint is by its own nature a contradiction, as it only provides one piece of work. The monoprint offers originality, unlike the traditional methods of printmaking which produce a limited edition of identical copies. The special appeal of acquiring a unique work of art is an important aspect for art collectors. Paintings are often too costly and as an investment present a greater risk, whereas monoprints, and in particular editioned prints, are usually less expensive. This is, of course, dependent on the artist and the work.

A more unusual process in the production of monoprinting is called a counterproof. The painter, Arturo Di Stefano uses this interesting technique in *Mirage*. He utilises this technique to produce monoprints from his paintings. See Chapter 2, for more work and details.

Monoprinting has recently been used by New York artist Susan Rowland to commemorate the tragic events of 9/11, at the World Trade Center, New York, 2001. The artist started this series of monoprints during the winter after the attack. Prior to this date she had researched and worked with city weeds from parking lots, cracks in the sidewalk,

▶ Arturo Di Stefano, *Mirage* 1997, 60 × 70 cm (24 × 28 in.).

Susan Rowland, April 11 2002: *Bindweed West at Liberty – 40°42'41"N / 74°60'43" W*, May 6 2002: *Parking Lot at Liberty & West Street, 40°42'41"N / 74°60'43"W*, and August 11 2002: *Paulonnia. Grate on Greenwich Street, 40°42'41"N / 74°60'43" W*, from the series *9/11:The Season After*. The latter part of each title refers to where the plant was found growing, and the artist has stamped the latitude and longitude (of the centre of the World Trade site, the target) onto each print.

gutters and demolition sites. During the spring of 2002 she visited the destruction area to look for signs of new growth on which to base a series of work.

The plants she found growing near Ground Zero were placed on an inked Plexiplate™ with paper laid over and printed at various pressures, depending on the thickness of the weed. The actual plants became stencils and the early impressions were coloured by the plants' juices. In printing, weeds were flipped for the ghosts and the plates were then re-inked to attain positive and negative images. These prints are a true archive of what she found growing in the area from seeds that had been under the rubble and ash.

Monoprinting is also a fairly quick way for artists to fully explore new themes, images and ideas. This working style can be used as a proofing process, with the option of taking the image further into an edition. Its eclectic character is the essence of its nature and as such anything is possible.

Certain artists have chosen to produce prints in an edition, which are then individually treated with paint or other materials. The result, therefore, ceases to be like a normal edition, as each print is no longer identical to the others.

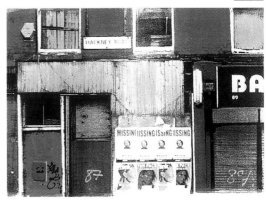

▲ Janet Brooke, *Missing on the Hackney Road*, 1999, screenprint, 55 × 75 cm (22 × 30 in.).

◄ Dee Whittington, *Pop Heart III*, 1994, screenprint and collage, 115 × 150 cm (44 × 60 in.).

Mistakes in editioned prints can be developed and resolved as a monoprint, either by combining processes or using aspects of them as collage to enhance other works. These interpretations can be processed using different colours, papers and the combination of many techniques. More and more artists are choosing to produce unique works. This doesn't mean there is no longer a future for editioned prints; rather it has extended the availability of different works on the market.

Another advantage of monoprinting is that it is not essential to have workshop facilities, such as a press. Artists can easily adapt their working environment. Many styles of monoprinting use simple equipment like a kitchen table, stable surface, or a makeshift workbench, on which materials such as simple stencils or found objects can be easily used to create fun and exciting artworks.

For more experienced printmakers, this genre brings new possibilities to

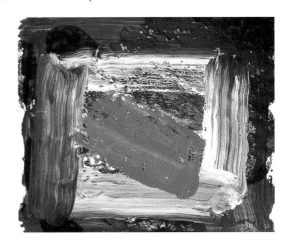

▶ Sir Howard Hodgkin, *Norwich*, 1999, etching with aquatint and carborundum, 41.5 × 47 cm (16 × 19 in.). Although the print was run in an edition of 80, each of the prints was developed independently, and can therefore be described as unique. (Work supplied courtesy of Alan Cristea Gallery, London.)

▲ Willie Cole, *Sunflower*, 1994, 200 × 195 × 10 cm (80 × 78 × 3.75 in.).

explore and combine a wide variety of skills. It offers an opportunity to demonstrate knowledge and expertise, which can be extended beyond the usual boundaries. African-American artist Willie Cole has produced a monoprint entitled *Sunflower*, using scorching irons on canvas and lacquer on padded wood.

This book is designed to inform and explain the various, sometimes traditional methods of printmaking and how these skills can be incorporated in monoprinting. It is hoped that the book will inspire readers to experiment and enjoy this exciting medium.

1 ■ HEALTH AND SAFETY

All artists should be aware of health and safety procedures in the workshop and how these practices affect the production of their prints. COSHH (Control of Substances Hazardous to Health) is the official authority in the UK that oversees the application of safe practice in schools, colleges and workshops. Similar rules and authorities exist in other countries.

Due to recent improvements in health and safety new materials have been introduced to minimise risk. Water-based inks are now a safer alternative to the previous oil-based range. They can be easily cleaned with the use of water and detergent, reducing the potential hazards for cleaning and removing oil-based products. It is important to note that water-based inks are not time-tested, therefore the future effects of these materials cannot be predicted. However, industry and technology are constantly striving to improve and test new products.

The following rules are common sense and easy to follow and apply:

When using a press
- Ensure your clothing is suitable and protective, e.g. do not wear loose clothing.
- Make sure that your hair is secured and preferably jewellery removed.
- Be aware of where you place your hands and fingers at all times.
- Stand away from presses if working with others in a print studio.
- Do not turn on electric presses until ready to print.
- Ensure adjustments on the bed are not made when the press bed is moving.
- Do not eat or drink in a print workshop because toxins can be accidentally ingested.

When preparing and cleaning in the studio
- It is preferable to use paper towels instead of rags because they are a cleaner and a more environmentally-friendly alternative.
- Tidiness and organisation are important for safety, so always prepare and clean the work area.

When dealing with fumes
- It is vital to ensure you are working in a well-ventilated area.
- If an extractor fan is not available, open windows.
- Ensure that a mask is always worn.
- Never inhale solvent fumes.

When dealing with solvents

- Solvents should be clearly labelled.
- Solvents must be stored in metal dispensers and kept in safe storage or a cabinet.
- Solvents should be kept well away from any heat source.
- Masks and rubber gloves should be worn when handling inks and solvents to avoid toxins entering through the skin.
- A barrier cream should be used whenever possible.
- A good hand-cleanser should be used to remove all traces of ink, followed by hand-cream.
- Never wash your hands with solvents because they are highly toxic and will penetrate the skin.

▼ Lisa Milroy, *Zebra 1*, 1997 is both a charming and conventional study that is described as a lithographic monotype. Its total size displayed in mount is 84 × 116 cm (34 × 46 in.). (Courtesy of Alan Cristea Gallery, London).

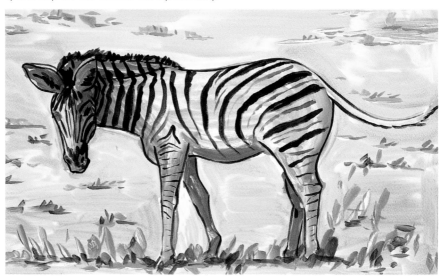

2 ■ MONOTYPES:
THE PAINTERLY PRINT

The painterly print is traditionally recognised as a spontaneous process to develop ideas within printmaking. This medium is effective, convenient and does not necessarily require a press. It is therefore economical, and can be printed by hand to any scale. Materials can include paints, inks, pastels and crayons (water- and oil-based), or combinations of materials painted directly onto surfaces.

Many surfaces can be used in monoprinting. These include wood, aluminium (or old litho plates), glass, clear Perspex™ or plastic. The latter three are particularly useful as they can be placed over a previous drawing on white paper, their transparent surfaces acting as a useful guide making the drawing easily visible, which is useful when creating new work. It is also a convenient gauge when judging the clarity and quantity of ink and colour. This guide can also be used as registration for further printing. However, it must be emphasised that glass should never be used with a press.

When artists think of monoprints they usually associate its method with the painterly print, otherwise known as a monotype. The artist Maggi Hambling, best known for her paintings and sculptures of famous characters, favours this painterly method of monoprinting. In her prints from the *Jemma* series she worked with Frank Connolly, the artist in charge of printmaking at Morley College, London where these monoprints were made. She drew into previously inked metal plates using turpentine, rags, her hands and occasionally a brush to remove ink and create the image. When the physical interaction of turpentine and ink had reached its conclusion,

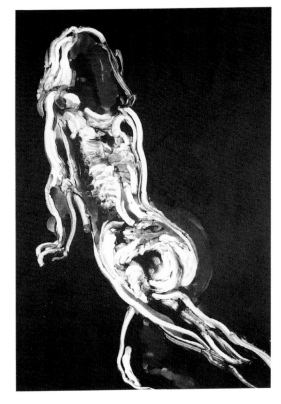

▶ Maggi Hambling, *Jemma Leaning*, 1991, 60 × 45 cm (24 × 18 in.) showing the painterly print technique.

◀ Perspex plates.

▼ Different materials used in a monotype.

Frank Connolly finalised the printing process using an etching press.

Another advantage in making painterly prints is that a variety of materials can be used for printing onto, for example, paper, canvas, plastic, clay, etc., and the printing process can be repeated as desired. Imagination is virtually the only boundary in this medium.

Monotypes vary significantly from being simple, single prints made without a press, to more process orientated prints. The latter can involve multiple runs and layers using a printing press, as in John Jacopelle's *Boat Ride*.

Generally, the advanced printmaker has access to workshop facilities and can produce monotypes using a variety of printmaking equipment. Etching presses were used in the production of *Cross Roads II* by Toni Martina and *Diana's Dish* by John Jacopelle.

In *Picnic II* and *Picnic III* by Alan Cox, the artist used a litho press several times to create each print. Alan Cox is a master-printmaker who established the world famous professional workshop Sky Editions, London.

◀ Work by Caterham School student Kaltumi Lawal, which was produced in a group monoprint workshop.

▲ John Jacopelle, *Boat Ride*, 2001, 30 × 40 cm (12 × 16 in.). Three print runs using multi-plates. The artist painted black over the first pull and used impasto on the third plate.

▼ Toni Martina, *Cross Roads II*, 32 × 45.5 cm (13 × 18 in.).

▲ John Jacopelle, *Diana's Dish*, 30 × 45 cm (12 × 16 in.).

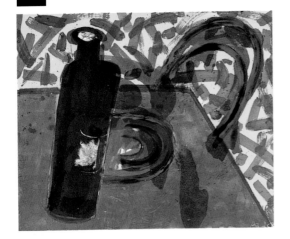

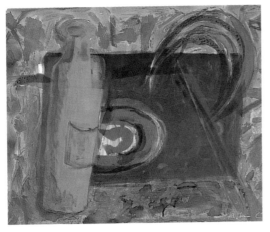

▲ Alan Cox, *Picnic II and Picnic III*, 1995, 60 × 79 cm (24 × 32 in.).

Materials and equipment for monotypes

Making monotypes is very similar to the painting process in which paint is applied to a surface. Oil-based inks and paints are the traditional materials used for monoprinting and are still very popular for many good reasons. However, before using these and the relevant solvents necessary for cleaning and mixing (such as turpentine, white spirit and methylated spirits), it is important to be aware of the relevant health and safety procedures and incorporate them into everyday workshop practice (see Chapter 1).

The colours in oil-based inks are known to be durable and time-tested. They are strong in hue, can be easily manipulated for thinning or thickening and artists have long favoured them for their rich, lustrous viscosity.

Inks are purchased either in tins or tubes. When initially selecting colours, do not to be seduced by the vast range available on the market. For economy, a limited palette is all that is necessary. It is therefore recommended that the three primary colours (red, yellow and blue) plus black and white are all that is required to begin work. The mixing of these colours will yield a surprisingly broad spectrum. More colours can of course be added.

Tubes are usually more expensive than tins of ink, but they offer the advantage of no wastage, because once a tin of ink has been opened the ink will form a skin and crust on the surface and hard lumps can form which affect the consistency of the product. To prevent this happening, pour a little water on top of the ink in the tin, then place a circle of greaseproof baking paper over it and replace the tin lid, resealing with masking tape to secure. This can cause the tin to rust, but it will help to retain the consistency.

Another useful tip is to purchase empty white metal open-ended tubes which are inexpensive, and transfer the entire contents of a tin of ink into these tubes. This can save a considerable amount of money and retain perfect ongoing smoothness.

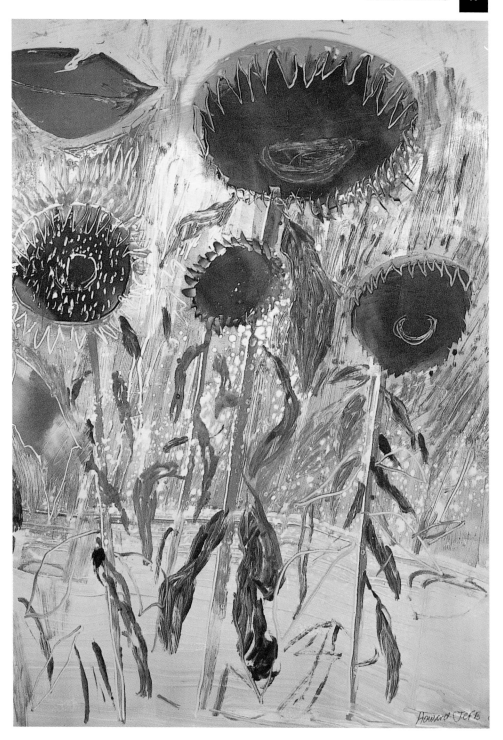

▲ Howard Jeffs, *Sunflowers*, 2004, monotype, painterly print, 76 × 58 cm (30 × 23 in.).

MONOTYPES: THE PAINTERLY PRINT

▶ A colour wheel. The three primaries have been mixed together to create the secondary colours. Tints have been mixed with white and these are in the centre. Shades, mixed with black, are found on the outer circle.

The addition of solvents such as turpentine and methylated spirits can be used to create texture and stipple patterns, either singly or in combination, as follows:

- Roll or paint oil-based ink onto surface of plate.
- Add a little solvent to the plate by spraying or flicking with a brush; an old toothbrush is perfect for this purpose.
- The effect is arbitrary because both solvents will give a different effect when dissolving the oil-based ink.
- Using a press is preferable, to pick up all the subtle nuances.

▼ Jackie Newell, *New England Fall*, using oil-based inks and solvents, 55 × 45 cm (22 × 18 in.).

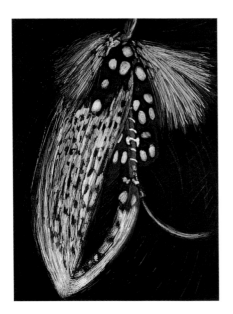

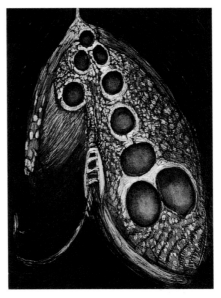

▲ Susan Rostow, *Trout Fly I* and *Trout Fly II*, 2000, 55 × 75 cm (22 × 30 in.). These prints were made using the multi-plate monotype method of printing, involving several different colours.

▼ Debra Arter, *Sun Vision*, 2004, 48 × 35 cm (19 × 13¼ in.). This print was created at a workshop using Akua Kolor™ water-based monotype inks.

Water-based inks offer an excellent, safe, non-toxic, fume-free and easily cleanable alternative to oil-based inks. They are worth experimenting with and are available from a number of manufacturers. Perseverance in working with these new products is certainly recommended, as they offer excellent results without any potential damage or risk to health. There is a wide selection available. They can be opaque or diluted with water for a more transparent glaze, while extender base and other products are available to increase the range and possibilities.

In *Trout Fly I* and *Trout Fly II*, the artist has used her own product, Rostow & Jung's Akua Kolor™, and both her prints illustrate the fabulous jewel-like colours available

in this range. Although these inks were originally developed for monotype printmaking, Akua Kolor™ can also be used for other techniques, such as Japanese woodcut and drawing on paper. It can be used directly from the bottle for brushwork or for rolling up thin coats of ink onto monotype plates. By adding the Akua Kolor™ Tack Thickener, the consistency will be improved for heavier applications. This product has a unique transparent quality that makes it ideal for printing many layers of ink, one on top of another.

Another artist who has used this excellent range of inks to produce a monotype is Debra Arter. In her print *Sun Vision*, (page 21) she loosely painted a design on a Plexiglass™ plate using brushes of various sizes. She then used a very large roller to apply the blue Akua Kolor™ that had been made 'greasier' with a tack medium and rolled this colour over the image to cover most of the background, but not to obscure the painting. This plate was then printed with Hahnenmuhle Monotype paper.

The Akua Kolor™ range also features ink containers which, combined with the various types of nib applicators, provide lines of various thicknesses to include calligraphic possibilities to prints if desired.

Many manufacturers produce conventional water-based inks, which are retailed in tubs, tubes and jars.

Transparent base is an important medium available in both water-based and oil-based inks. When mixed with colour, this medium allows artists to

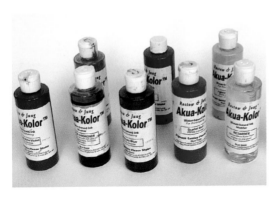

successfully layer ink and build up glazes. Multiple printing produces exciting colour development as is evident in Wayne Viney's *Weather No.1* (page 27).

For those who prefer to draw using colour sticks, Caran d'Ache™ water-based crayons are a perfect choice and can be drawn directly onto a plate of clear Perspex™, or smooth or frosted Mylar™. This process can take place anywhere, anytime prior to printing. Frosted Mylar™ is recommended if more control is required, as its surface has a tooth that helps to prevent 'bleeding'.

◀ (top) Akua Kolor™.

◀ Jackie Newell, *Orkney Nest*, 2003, 15 × 10 cm (6 × 4 in.) on John Purcell Paper Zerkall 602 rough paper using Akua Kolor™ inks.

Caran d'Ache™ crayon is transferred by using damp paper, and the printed results are obtained only with the use of a printing press. It is important to note that the image must be dry prior to printing onto damp paper, otherwise the result will be smudged and ruined in the process of printing. Caran d'Ache™ has the advantage of combining both painting and drawing, and these styles can be used singly or together.

The beauty of this method is that you can achieve effects similar to that of a watercolour by using water and brush and diluting the drawn images of the colour sticks. Another advantage of this technique is that drawings can be made and stored for several days before printing.

When using Caran D'Ache™ it is important to select the correct paper. It is advisable to use textured papers such as Arches or Somerset because smooth papers can be problematic as they may stick to the plate. Should the paper adhere to the plate after printing, it is advisable that both plate and paper be removed from the press and placed onto the clean surface of a pre-warmed hotplate at the temperature used for wiping an intaglio plate. Leave for a few minutes and then peel away carefully.

Tools used to apply or remove ink when making painterly prints include brushes, rollers, sponges, rags, palette knives, cotton buds and any mark-making or removing device. Experimentation and practice will allow artists to discover a variety of inventive devices to create unusual textures and marks.

Most materials are readily available from art supply stores specialising in printmaking, and these retailers usually employ staff able to give advice on technical aspects.

Printing

For those with no access to a press, or who prefer to work without one for printing, a clean rubber roller is ideal to transfer an image onto paper, as are Japanese and mechanical barens. Otherwise, you can use household wooden spoons of various sizes, preferably flat like Japanese rice

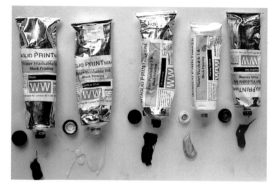

▶ (top) Nibs and applicators.

▶ Tubes of inks by Intaglio Printmaker, London, who retail an extensive range of printmaking material, including their own excellent brand. This product was used in Jackie Newell's *Red Shoes*.

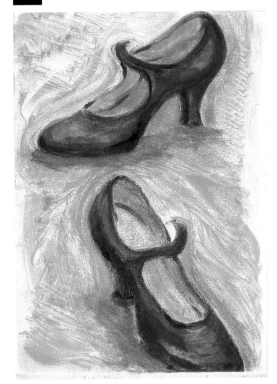

◀ Jackie Newell, *Red Shoes*, 2003, water-based inks by Intaglio Inks, 50 × 60 cm (16 × 24 in.).

spoons, which are available from oriental food stores. It is advisable not to use metal spoons, as they get hot and have been known to tear and damage paper.

Setting up the correct pressure on the printing press

It is important for those with access to a press to select the correct pressure. This should be done with clean hands, prior to commencing the printing process, i.e. before mixing inks.

- Take a clean plate the same gauge as that which is to be printed.
- Place over it a clean sheet of blotter paper.
- Cover these with printing blankets and run through the press.
- The plate mark should not be as evident as that produced by intaglio printing, otherwise the subtleties, which are characteristic of monotypes, would be flattened.
- There should be just sufficient pressure to transfer the inked image.

Various printmaking mediums use different presses and these are illustrated in the relevant chapters.

▲▲ Jackie Newell's example of Caran d'Ache™ colour strips, printed on Somerset textured 250 gsm cream paper, supplied by John Purcell Paper.

◀ Tools used to apply or remove ink.

▶ Jackie Newell, *Sacrifice*, 2000, Caran d'Ache™ water-based crayons, 20 × 15 cm (8 × 6 in.).

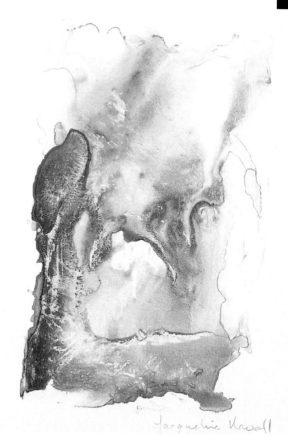

▼ Donna Moran, *Finding the Lost Continents*, 1994, Caran d'Ache™, 55 × 75 cm (22 × 30 in.).

The table top etching press, made by Polymetaal and sold by Intaglio Printmakers, London, is a portable press and useful for printing both etchings and relief work.

Too much weight can cause the ink to 'squidge' and smudge, possibly causing damage to the press blankets. It is advisable that when printing monotypes a sheet of smooth, thin, clear plastic is placed over the reverse of the backing paper for further protection. Felt or old blankets are ideal for printing monotypes.

Should sufficient ink remain after printing it is possible to make a second image. This is called a ghost print, which is a fainter version of the former. This faint 'ghost' can be used to make further prints that will be similar but not identical. It is also possible, at this stage, to take the image further. Ghost prints are of course possible using other methods of printing.

An alternative to painting ink onto a smooth surface is to use a screen (as used with screen presses). Such images can be painted directly onto clean open screens and the ink pulled through the mesh onto the paper below, using a squeegee (see Chapter 4). Such 'open screen' print runs can continue to be made until the image is complete, but the ink must be allowed to dry between each pull of colour. It is essential that the paper never be pre-dampened.

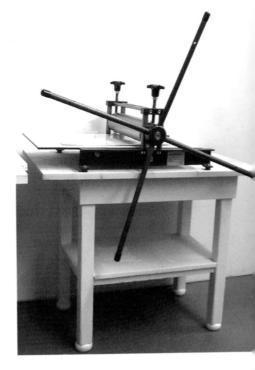

▶ (top) Table top etching press.

▶ (centre) Rollers and inks.

▶ Spoons and barens.

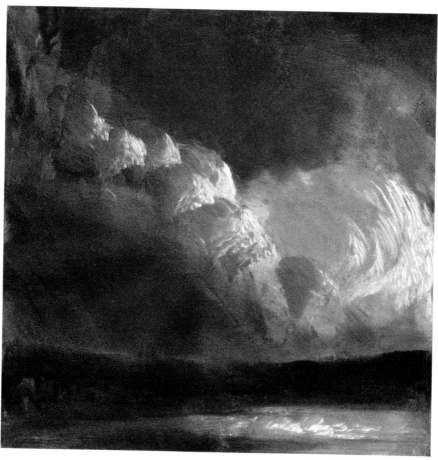

▲ Wayne Viney, *Weather No.1*, 2003, multiple plate print, 17.5 × 17.5 cm (7 × 7 in.).

Printing papers

A fabulous selection of beautiful papers is available from most printmaking suppliers and artists can be spoilt for choice. However, the everyday standard papers should not be overlooked, as they are both inexpensive and easily available. Discarded and household materials are often useful, such as brown paper, tissue, tracing or greaseproof, writing and even printed papers; all these can be incorporated into images making them more interesting. It is important to note that coloured and textured papers can sometimes make too strong a statement and are best used selectively.

Printing papers are available in various weights and colours. The choice for the printmaker is determined by method and whether a press is available.

Finer papers, e.g. Japanese, Indian, Nepalese, Thai, or others weighing approximately 70 g, are more sensitive and therefore suitable for hand-printing, collage and *chine collé*. Heavier papers, 150 gsm upwards, such as

▲ Falkiners Fine Papers.

▲ John Purcell Paper.

Somerset, Arches and Rives BFK, are more suitable for printing with a press. More detail can be achieved if pre-dampened paper is used. However, the choice is very much down to the individual artist.

Preparing the single plate

The technique that is most popular with many artists is the single plate method of monotype printing. This is as follows:

- Take a clean plate, which can be either glass, Perspex™, plastic or smooth metal.
- When using a press it is recommended that the edges of the printing plates be lightly bevelled to prevent cutting the paper and also the press blankets. It also makes it easier to wipe the edges of your plate, and helps prevent dirty plate marks, which are unsightly on fine art prints.
- Prepare your working area: to keep this clean, place newsprint on flat surface.
- On to this place a sheet of white paper, which allows visibility if using a transparent plate to gauge true colour.
- On top of this place the plate.
- Prepare your palette with chosen colours, ensure the correct ink consistency, which should be similar to soft butter, and add a little copper-plate oil or Graphic Chemicals Easy Wipe™ if using oil-based inks. If using water-based ink and it is a little stiff, mix in a couple of drops of washing up liquid for the desired viscosity. When mixing inks try not to use too much. This not only avoids wastage, it is also easier to add than to remove. Temperature and humidity can affect the viscosity of the ink, which must be smooth and devoid of any lumps or grit.
- If using a roller, a separate slab should be used where ink must be spread evenly across the middle like a ribbon, then rolled until roller and slab are both evenly covered. The ink is then ready to be transferred to the working plate.

- Once the plate has been inked evenly, various methods can be used to remove ink and expose clean areas to create image and texture. Such methods include the use of cotton buds, rags, paper towels, etc. Further marks can be made using fingers, palette knives, brushes and sticks of varying thicknesses.

Registration of the printing plate

Registration is the placement of paper to plate. With a monoprint, as with all prints, registration is essential so that you can return to the printed plate as often as you wish to add more colours, details, etc. (to do this you need to place the paper on the plate in the exact, same position). There are various methods of registration, but for the printing of a single plate print the following registration technique is recommended:

- To create registration in the production of a bleed print, (an image printed to the edge of the paper), the paper is torn or cut to the exact size of the plate.
- It is important to make a corresponding mark on both paper and plate and to continue to align to the same right angled corner. This way the paper can be repeatedly printed and registration will remain correct.
- For an image smaller than the size of the plate being used, a Perspex™ plate provides the perfect solution for alignment. This is because paper size can be marked on the reverse of the transparent plate with an indelible marker.
- To create an image within this boundary excess ink must be removed from the marked area and care taken to wipe clean the surrounds, otherwise the registration marks will be concealed and the border will be dirty. For a speedier method, use four strips of clean newsprint to mask the four borders.
- Printing paper should be prepared in advance, having been cut to the desired size and marked on the reverse side in pencil. This prevents any misplacement in further print runs.
- When the monoprint image is ready for printing, place the plate on the designated area of the press (or printing area) and lay the paper face-side down over the inked plate.

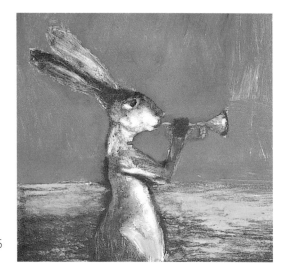

This registration method does not produce plate marks. Should you require plate marks, which can be aesthetically pleasing, then the paper must be larger than the plate and can only be obtained when using a printing press.

▶ Chris Salmon, *Musical Hare*, 1992, 55 × 75 cm (22 × 30 in.), printing ink on zinc plate.

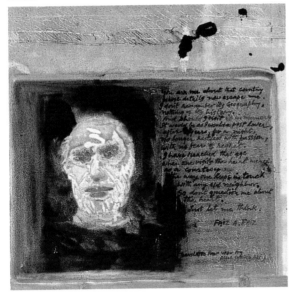

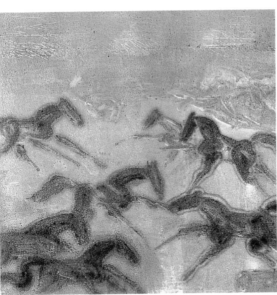

▶ (top) John Jacopelle, *Penelope Pickings*, 2000, painterly print using oil-based inks, 30 × 40 cm (12 × 16 in.).

▶ (below) Susie Hamilton, *Dog Headed*, 2003, 28 × 38 cm (11 × 11 in.), part of a series on baboons and monkeys, printed on a Brand™ etching press.

◀ Vijay Kumar, *Let me think* (Faiz), 2003, 29 × 30 cm (11¾ × 12 in.), lettering added after print was dry, watercolour, brush and loose etching ink.

▼ Vijay Kumar, (left) *Untitled*, 2003, 29 × 30 cm (11¾ × 12 in.), monotype using etching ink.

▼ Zara Matthews, *Chromosome Series (Head)*, 1996, 28.5 × 25.5 cm (11 × 10 in.), etching ink on Somerset paper

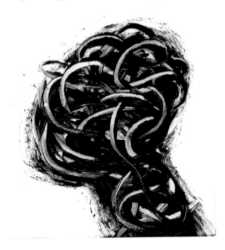

Printing the single plate

- With your paper in place over the correct registration, take a piece of either clean tissue or newsprint to protect the back of the printing paper and place over these.
- If you are not using a press, the easiest way to transfer the image is to use a clean rubber roller. For a lighter effect use a bamboo or mechanical brayer. Flat wooden Japanese spoons are preferable to ordinary wooden spoons for an even transfer. If you use a wooden spoon or door knob make sure you

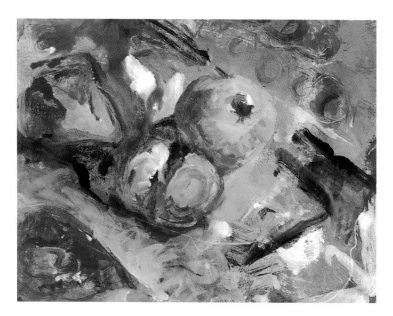

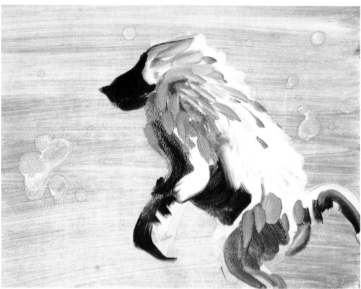

an even transfer. If you use a wooden spoon or door knob make sure you burnish the area evenly, e.g. start from left to right and continue.
- To view the image without removing the paper, place one hand firmly on the back of the paper and peel it back from the corner without removing it entirely from the plate. If more pressure is desired then drop it back carefully and reapply greater force. Less pressure creates a lighter image, greater pressure produces a stronger result.

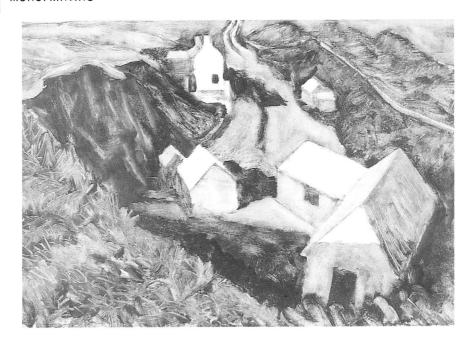

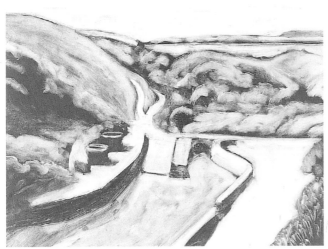

▲ Simon Burder, *Wilderness & Community*, 1992, 28.5 × 38 cm (11 × 15 in.).

◀ Simon Burder, *Harbour*, 1992, 28.5 × 38 cm (11 × 15 in.).

Registration of multi-print plates

For perfect alignment of multi-plate prints, use the following technique:

- Take one sheet of acetate (because it is easy to clean, is re-useable, can be stored in a drawer or portfolio and can be transported simply to a communal workshop). The size chosen should exceed the size of printing paper.
- Take one sheet of graph paper that exceeds the size of printing paper, and mark 'top' before taping it under the sheet of acetate. A good tip is to draw the various sizes of paper that are generally used onto the graph paper as a guide, so that the plate can be easily positioned within the correct area.

- Within that area mark out exactly where the plate is to be placed.
- If you are using a press, tape the corners of the acetate lightly onto the bed of the press to prevent movement.
- Place the inked plate on the marked designated area for the plate, with the ink side up.
- If intending to multi-print, always align to the same right angle, i.e. the top left side.
- Lay the paper onto its own designated area and hinge the top corners with small strips of masking tape.
- Be careful when removing this tape after printing not to damage the paper. Preferably allow the paper to have a little extra margin, so if damage occurs the print paper can be trimmed.
- If printing multi-prints ensure all the plates are inked and ready to print.
- When multi-printing, and between pulls, carefully lift the paper back on its hinge and replace the plate with the next plate to be printed in the exact same position and continue until the print is complete.
- Ensure each plate is aligned for registration, with the correct area facing the top.
- When printing is complete, remove the masking tape and lift the print off for drying.

▲ Registration maquette.

▶ Howard Jeffs, *Coronet*, 49 × 64 cm (19 × 26 in.).

▶ Merlyn Chesterman, *Girl from Drukgyel*, 2001, 25 × 19 cm (10 × 7½ in.).

▼ Caterham School student Oliver Moylan, *Engine*. Moylan produced both his prints in a workshop run by Jackie Newell.

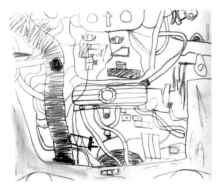
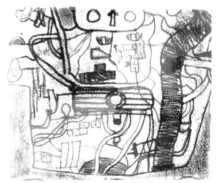

Transfer monotypes

To produce a transfer monotype you can use either water-based or oil-based inks as both are suitable for this method. No press is necessary. Materials required are the usual smooth surface, pencils, crayons or sticks of varying thicknesses and a clean, soft roller for applying ink. Paper of medium weight is advised, bearing in mind that the lower weight papers such as 70 gsm are more receptive to impression and greater detail.

To make a transfer monoprint, the following procedure is recommended:

- Take a sheet of Perspex™ or Plexiglass™ and roll a thin, even layer of ink over the surface.
- Should you wish to create a clean border around your print, take four strips of newsprint and place them around edges of the plate to create a mask.
- Place a sheet of paper directly on top of the inked block, securing the top two corners with masking tape to prevent it slipping. This will allow you to lift the paper at any time during printing to observe the results.
- You can either draw freehand from observation directly onto the paper or take a sheet of tracing paper with a pre-drawn image and secure it over the existing paper using the same method.

- Using a combination of pencils and crayons, copy the traced drawing, applying various pressures to achieve different lines. The tracing paper will protect the back of the printing paper as the drawing will be confined only to this surface, and it will also prevent the printing paper from tearing.
- With a little practice, effective results can be achieved and over-printed, if desired, using extra plates inked with different colours. Effects can

▲ Workshop with students from Caterham School.

be similar to a soft ground print, as achieved in traditional etching techniques, or a charcoal appearance can be obtained, with soft, smudgy lines. Tones can be achieved by applying different pressures with your fingers in designated areas.

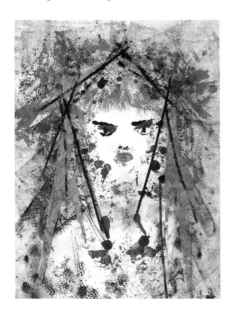

▲ Sam Gurney, *Chopsticks*, 2005, 42 × 30 cm (17 × 12 in.).

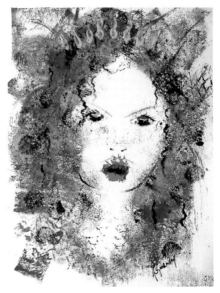

▲ Sam Gurney, *Bewitched*, 2005, 21 × 30 cm (8 × 12 in.). The artist has used the same transfer process as shown left, imaginatively incorporating collage, textured ephemera and the painterly technique into these bright monoprints.

Cleaning, drying and storage of monoprints

Cleaning

As a safe alternative to solvents for cleaning, vegetable oil followed by washing up liquid will remove oil-based ink from all working surfaces and equipment. To remove any residue of grease from the press bed, sprinkle a little white chalk and wipe with a paper towel. All paper towels must be sealed at the end of the day in large refuse bags for disposal and their contents labelled.

Water-based inks can be cleaned away with water, washing up liquid and a sponge. Drying can be undertaken using cotton rags from old sheets and shirts etc. which can be washed and reused.

Ink rollers can be washed in warm water and detergent when using water-based inks. Oil-based ink can be removed with either turpentine, white spirit or, for a non-toxic option, use the combination of vegetable oil rinsing with detergent. Always make sure rollers are dried thoroughly, and to prolong their life dust them with a little white chalk or talc to prevent the rubber from perishing. To store rollers they should be either hung up on a hook or placed on a guard to prevent the rubber from touching a surface and becoming damaged.

Drying

Normally prints can be press dried between tissue, blotters and board blocks. However, if they are highly textured it is preferable to air-dry prints. It is fine to leave them on a flat surface or on ball dryers, providing the paper is not pre-dampened. If the paper is damp, air-drying will cockle the paper. In such cases use a fibreboard; place the prints on this and staple the edges evenly so that when the paper dries and contracts it will remain taught and flat. Always allow an excess margin to allow for later trimming.

Oil-based ink takes at least three days to dry. Water-based inks can be dry within hours, depending on the thickness of ink and the temperature that day.

◀ A drying rack.

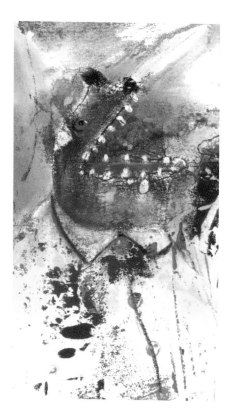

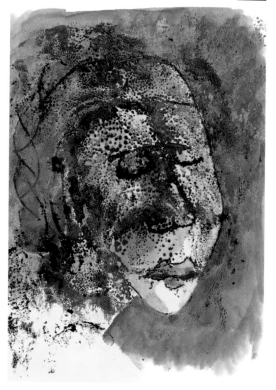

▲ Tor Hildyard, *Laughing Dog*, 2003, 23 × 10 cm (9 × 4 in.). The artist drew into the cleaning slab with oil pastels, then placed the paper on the inking up surface. The outcome is both spontaneous and witty.

▲ Tor Hildyard, *Turning Head*, 2003, 25 × 20 cm (10 × 8 in.). The artist placed the printing paper arbitrarily on the inking up surface during the cleaning process, then drew on to the back of this. She added watercolour at a later stage.

Storage

When prints are dry it is important to store them correctly. The following points will aid the artist in this area:

- All prints should be clean and signed in pencil.
- Prints should be laid flat in a plan chest or flat file, away from direct sunlight.
- Store prints in a plan chest in a dry room with cool, even temperature.
- Prints of similar size should be stored together.
- Each print should be interleaved with acid-free tissue or Glassine paper.

3 ▪ MONOPRINT BASICS: FIRST STEPS

▌Stencils and masks

Stunning results can be achieved using simple techniques utilising masks and stencils, with or without a press. Stencils and masks used to create basic monoprints can be any object with a surface pattern.

Offset, or counterprinting, is a product of this basic *genre*, whereby a roller can pick up the image from the inked object to be transferred onto new and existing work. This can be taken further by repeating the process of transferring the offset image onto the plate as many times as required, always using a clean roller before applying fresh ink.

Using several applications this process can produce a multitude of colours in one print, as is seen in Ann Bridges' *Feathers*. In this image the artist has worked directly onto the paper surface, using hand-rollers to apply inks and also stencils to define and mask areas of the composition. She used old biros, cloth and fingers to scratch into, or wipe away, the ink. White spirit was also used at various stages, sprayed on or applied with cotton buds. To achieve such stunning colours, drying times are crucial. In between each colour application the ink must be allowed to dry.

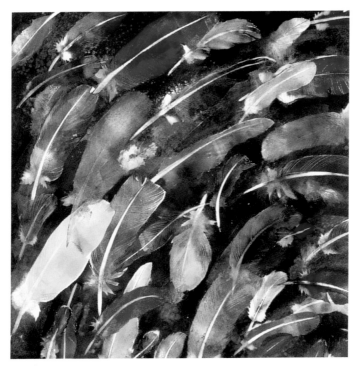

◀ Ann Bridges, *Feathers*.

Many resources can be used to create suitable stencils and masks, examples include lace, textured materials and many natural objects such as leaves, fruit and vegetables.

Multicolour basic prints

Wet ink on wet ink is also possible when using stencils, the advantage of this technique being to produce a multicolour print in rapid consecutive printing. Jackie Newell used this technique in *Circuit Board*. Careful preparation is essential and negative/positive printing can also be incorporated, a technique in which a mask is cut, printed and then used as a stencil to resist ink when placed in position. When peeled off the plate, it can then be reversed to utilise the ink that has been transferred from the plate during previous printing.

To achieve multicolour printing, accurate registration marks must be made either on your press bed, or on a sheet of plastic if printing by hand (see Chapter 2). Take a number of separate inked blocks of identical size (e.g. primary colours) and onto these place the chosen stencils from suitable materials that are low relief and not jagged or sharp (damage can be caused to the press and blankets as a result of careless stencil use).

When using a press the following procedures need to be observed:

- Always gauge the correct pressure by placing onto the press bed an un-inked block, backed with dry blotting paper and pass this through press in order to determine an appropriate impression. Too much pressure results in wrinkled paper and 'bleeding' of ink, which, as well as being undesirable, can damage the blankets. Ideally pressure should be less than for intaglio but sufficient to produce detailed work.
- Take an inked block, e.g. yellow, (it is always best to work light to dark) and place it ink side up directly onto the pre-drawn registration marks on the press bed.
- Place prepared, pre-dampened, blotted, printing paper over the block within the registration marks.
- Secure the top two corners with masking tape and hinge.
- Place tissue paper over the printing paper, pull the blankets tight and smooth them over, ensuring no wrinkles or folds before running through the press.

▲ Example for students, by Jackie Newell.

▲ One person's rubbish can often prove to be another's treasure; some items otherwise discarded can be utilised with imagination.

▲ Jackie Newell, *Circuit Board*, and its ghost print (right) are both made from items normally thrown out at the end of an office day. These prints use circles from a hole punch (like confetti), torn edges of plastic sleeves, negatives from old photographs, string, cotton and hand-cut geometric shapes. They were created using oil-based inks printed on pre-dampened Somerset Textured paper.

- After first print run, carefully lift the hinged paper and remove the block. Remember to note which is the top of image, then replace it with the next colour block (e.g. red) in exactly the same position.
- Repeat the process until all blocks have been used.
- At this stage you may wish to add some of the stencils that have been used to create negative shapes and flip them to print the reverse side, as they will be inked from previous print runs. They now print as positive images.

It is advisable when printing undried, organic matter such as fruit or vegetables to print by hand only, as using a press will cause damage through juice spillage. You could of course use light pressure and sheets of plastic, but great care is advised.

This same procedure can be used without a press using a wooden spoon, clean roller or baren.

Body masks and stencils

The human body has always been a marvellous resource for artists, particularly for self-portraits, as the model in question is accessible at all times and within the budget. Taking the principle further is the use of body prints where artists can make replicas of elements of their own body or that of others. Prehistoric peoples created rock-art images using their own hands as a stencil, with paint made from natural pigments (such as red ochre crushed to powder mixed with water). This would have been one of the earliest uses of a stencil.

The artist Arturo Di Stefano has produced work with images relating to St Veronica. These are contemporary counterproofs which first occurred during his *Sudaria* portraits in 1986, the *sudarium* being the cloth that miraculously retained an impression of Christ's face when St Veronica wiped away his perspiration on the way to Calvary.

Counterproofs are generally produced by placing a sheet of pre-dampened printing paper directly over a recently printed image. The ink must

▲ Marilyn Kyle found the lace bustier stencil for her print *Corset I* in a local charity shop which, similar to thrift stores, are a wonderful source for obtaining potentially useful items.

be wet before running through a press for an offset to occur. However, in the counterproofs created by Arturo Di Stefano, the artist completed a traditional oil painting on canvas and then painted over its surface using a local colour to achieve a deliberately blurred effect. He then painted a thick layer of varnish over this and placed on to it a sheet of Japanese woodblock paper. This was pressed and rubbed on to the wet canvas, in order to soak up the excess paint. When the paper was removed it revealed an impression. The outcome is exciting, as definition can be random and the result is often unpredictable and mysterious, lending itself appropriately to the subject matter.

Helen Chadwick's *One Flesh* concentrates on what appears to be a modern day Madonna and child. Its imagery uses collaged photocopies. The artist chose a photocopying machine to produce prints of direct impressions of the body parts of a friend and her new-born baby girl, and compiled these to make a unique print. Of course, this technique could be used to produce an edition, but

▲ Arturo Di Stefano, *Veronica*, 1997, 72 × 55 cm (29 × 22 in.) oil on paper.
White Counterproof (right), 1997, 105 × 66 cm (42 × 26½ in.) oil on paper.

Chadwick chose to produce only one image. The final result is an extremely beautiful modern classic, reminiscent of Renaissance and iconic works of art.

Another way to include body imprints is evident in Jackie Newell's *Maria and Dulcia*. Here the artist used a rubbing from an epitaph, using lithographic transfer paper and a lithographic crayon to create the rubbing. This paper has two layers so that when the top layer is peeled carefully from the backing, it resembles an onion skin. The artist placed this element directly over a carved epitaph displayed in an old church and rubbed over the letters carefully with a lithographic crayon. The backing was then replaced and covered with clean paper for transportation to the studio. Next, a zinc plate was placed on the press-bed and dampened with water. The emulsion side of the transfer paper was placed face down onto the plate, the back was then sponged over with water and a plastic sheet was placed over the top, followed by blotters. This plate was run through the press several times to fully transfer the image, which was then rolled with ink as in the lithographic process, and stored for use.

When the lithographic print was completed, the artist used graphite dust over the wet ink to create an effect resembling stone. When the print was dry, the artist rolled up a slab of transparent base ink, pressed both hands onto it, then placed them strategically on the print itself, to transfer the ink and stencil imprint. This wet ink was then sprinkled with bronzing dust. Any residue was removed when dry.

Using imprints as both method and symbol to create monoprints is an option also used by the Chinese artist Hale Man. This artist's unusual

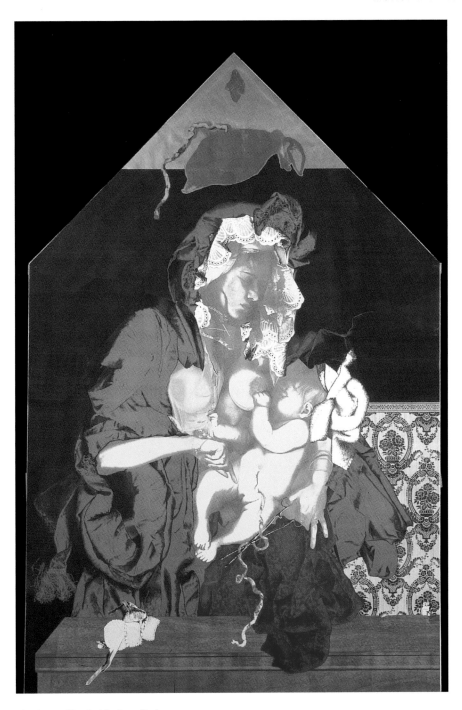

▲ Helen Chadwick, *One Flesh*.

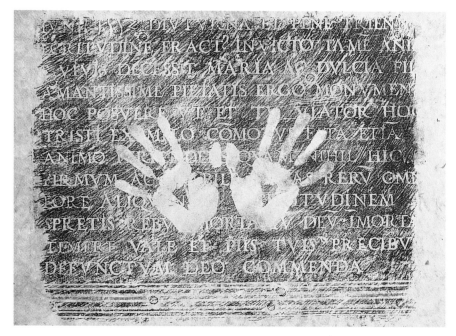

▲ Jackie Newell, *Maria and Dulcia*, 2002, 55 × 75 cm (22 × 30 in.).

modern interpretations of her cultural tradition have produced strong and exciting results.

The preliminary technique used by Hale Man was to draw using graphite and coloured pencils on watercolour paper. Colour was then applied to the soles of the artist's feet which she walked strategically onto the dampened paper to create the head-dress shape. The artist repeated the process using different shades of ink to develop the image further.

The work represents the feminine side of Chinese culture and the original studies were undertaken in a rare workshop of a master opera head-dress maker in his small Hong

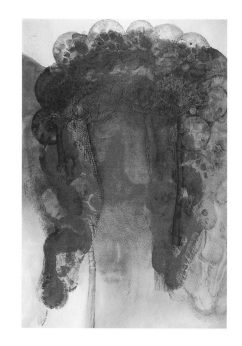

▶ Hale Man, *Bride*, 2004, 75 × 55 cm (30 × 22 in.), medium graphite pencil.

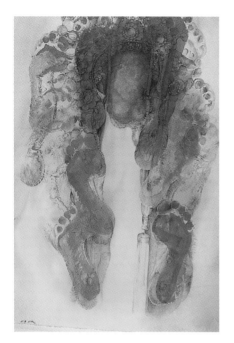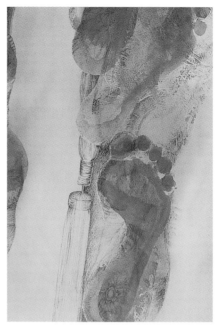

▲ Hale Man, *Princess*, 2004, 75 × 55 cm (30 × 22 in.), graphite pencil and footprints using white paint on paper (head-dress used in opera). Right: Detail of footprint from *Princess*.

Kong studio, where the artist was allowed to make drawings from primary observations of the beautiful creations for the Chinese opera. These monoprints are both intimate and personal to the artist, as her mother was a Cantonese amateur opera performer. The head-dresses symbolise the female journey in life and the use of footprints represents Hale Man's own life.

Monoprints using copier toner and transfer technique

Many artists currently have access to a photocopying machine, or a personal computer printer. These can offer an instant and easy method of reproducing images which, when combined with a printing press, can transform copied drawings into prints.

An unusual and somewhat safer alternative can be the use of citrus oil or nail varnish remover pads without acetone, which can be applied to the reverse of a photocopy. Such was the method employed in Dee Whittington's *Giuliano de Medici* which is the result of a 'happy accident'. The artist intended to produce a monochrome image from a digitally manipulated one, which was printed using a ink-jet printer. The result was expected to be similar to *Sailor Girl*, which had been printed on a laser printer, but this did not turn out to be the case, as different PC ink cartridges produce very different effects. The result was very pleasing due to the beautiful, subtle colours achieved from the black toner. The work is unique as the artist was unable to achieve any replicas.

In Dee Whittington's *Smiling Patron*, the process of inkjet photocopying using non-acetone nail varnish remover pads onto a digitally manipulated image was again used. In addition to this:

- the image was produced twice from the computer using an ink-jet printer: one on paper, the other on acetate;
- the paper copy was then transferred onto dry Somerset paper using the above method of nail varnish remover pads (without acetone);
- the artist took a Perspex™ plate the same size as the image and drew onto it (bearing in mind that it would be printed in reverse) with Caran d'Ache™ water-based crayons;
- the print on the Somerset paper was then sprayed with water, blotted and placed carefully over the Perspex™ plate, taking care to align for registration and run through the press;
- the acetate copy was laid on top of the Somerset print, affixed to it and cut to size; and
- the image was completed by drawing with Rotring ink.

The basic monoprinting technique offers impressive results that are also easy to produce and accessible to cautious beginners: object plus ink equals image.

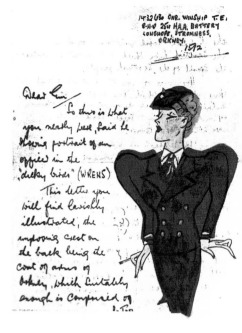

▲ Jackie Newell, *Sailor Girl*, 2005, 20 × 30 cm (8 × 12 in.). The image used was extracted from a letter, written by the artist's father to his sister whilst serving as a soldier during the Second World War.

▶ Dee Whittington, *Giuliano de Medici*, 2004, 20 × 15 cm (8 × 6 in.).

▲ Dee Whittington, *Smiling Patron*, 2003, 20 × 25 cm (8 × 10 in.).

4 ▪ RELIEF, CARBORUNDUM AND COLLAGRAPH: THE BUILDING BLOCKS

Relief, carborundum and collagraph processes are generally considered for editioned prints because they usually involve durable materials such as lino, wood, etc. However, they are often effectively used in monoprints and sometimes combined. Collagraphs and carborundum prints are generally associated with intaglio printing (see Chapter 6). As these surfaces are usually textured they can be top rolled and printed in relief, or they can be combined with intaglio, which means they can be inked and wiped in the intaglio manner in one colour and then using different colour/s and roller/s, top-rolled and printed.

Printing in this style can be versatile and exciting because of the many textures made possible by the medium. It must be stressed, however, that when using the top rolling method, the result is not as rich as in intaglio where ink is held like a conventional aquatint (see Chapter 6).

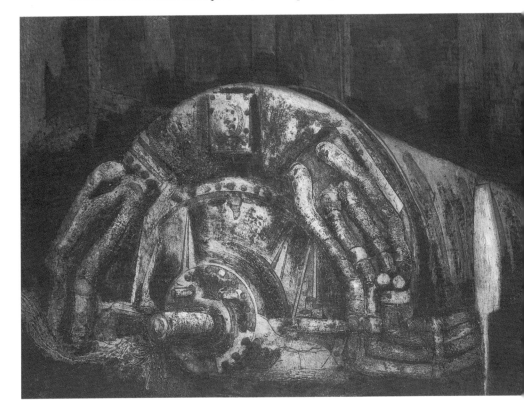

▲ Anne Desmet, *Towers of Babble*, 2002, 65 × 80 cm (26 × 32 in.). The artist has used type-blocks made of wood relief rolled in black oil-based ink. These were then printed onto various Japanese and Nepalese papers some of which were reversed when assembled in the finished collage, to produce a subtle and alternative effect.

◀ Jackie Newell, *Bankside Turbine*, 1995, 55 × 75 cm (22 × 30 in.).

In the methods discussed in this chapter, monoprints are produced by manipulating areas of the block. These processes can include:
- inventive inking and rolling;
- choosing specific areas to develop;
- employing different colour fields for unique prints of varying colour;
- individual hand colouring to finished prints; and
- adding collage in an arbitrary manner.

Development of specific areas is an essential part of monoprinting, as it allows creative individuality within the prepared matrix or base. A theme can be fully explored as individual prints can be manipulated during the creative process to develop specific ideas through alteration. This is unlike the constraints imposed by printing an edition.

The importance of using combinations of materials and techniques is often vital to the production of the unique print and the principal methods are described in detail below.

RELIEF, CARBORUNDUM AND COLLAGRAPH: THE BUILDING BLOCKS

▲ Jane Stobart, *Monoprint* 2003, 29 × 43 cm (12 × 17 in.). The artist used wooden letters, inked in relief and wittily assembled to spell the word and its title. This was printed onto Somerset Textured off-white paper using a letterpress.

Relief

A relief print is when the surface of the block is top-rolled to create the image. The uncut areas reveal the colour of the material beneath the printed area. The traditional choice of blocks used for relief printing is wood or lino. Wood has been used for centuries by artists including Durer, Rembrandt and Hokusai.

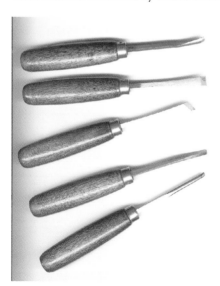

Lino, being a manufactured material, has been utilised more recently. The process using either of the materials is similar. Wood is distinctive because of its natural organic textures and the best results are achieved by cutting in the direction of the grain. In contrast, lino is smooth and easier to cut, particularly after being warmed on a hotplate.

The cutting tools for both wood and linocuts are similar in respect of their different shaped gouges and are used to cut away and incise a variety of marks into the block surface.

◄ Lino tools.

It is a good idea to begin by drawing the image on the block using black indelible ink. This will act as a guide to indicate the areas to be removed and those which are to remain. It is best to be economical with cutting and to proof print regularly in order to avoid over-cutting the desired image. Proofs are also useful as working drawings for preparing the next stage of cutting, as they can be painted over using white paint which helps to decide where next to cut.

Cuts are very important in creating detailed work, when working with either wood or lino. Therefore the sizes of gouges need to be varied and controlled. Tonality through textures can also be achieved by cutting different widths and lengths of line. This process encourages energetic mark making, often

▲ Ian McKeever's work *from Eight x Twelve*, 1997 (*Print E, Version IV*) 112 × 80 cm (45 × 32 in.). Courtesy of Alan Cristea Gallery, London.

producing exciting results. Ian McKeever's work *from Eight x Twelve* is an excellent example of a powerful and energetic relief print. The artist has chosen to work on industrial plywood, using large sheets cut into shapes, and into these he gouged deeply, using chisels, nails and even a jig-saw to create the thicker incisions. Rough lines were achieved by cutting against the grain and the fluid lines were made by cutting in the direction of the grain. This combination creates the print's ragged harmony. Although this image could be reproduced in an edition, the artist has chosen to vary the wiping and inking of each new print to produce subtle differences of colour and tone. The experimental nature of McKeever's work produces variations that are classed as monoprints.

Reduction method

A popular style of working in relief using either wood or lino is to use the reduction method, where many colours can be printed from one block. This process is normally associated with an edition. However, it is the artist's choice to decide on the edition number, or if the work is to be a unique print. Once the block has been cut, printed and re-cut there is no possibility of reprinting stages of the process.

When making a reduction print it is advisable for the artist to have a clear idea of the image they wish to achieve. This can be done by first drawing the

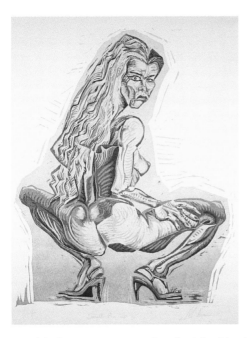

◀ Magnus Irvin, *Pin Up*, 60 × 45 cm (24 × 18 in.). An example of the reduction process.

image and indicating its colour areas, bearing in mind that the image will be printed in reverse. A reversal of the final image must therefore be planned.

The process is as follows:
- Registration is important, as each new colour must be placed and printed in exactly the same position (see Chapter 2).
- If the artist wishes to maintain the colour of the paper as part of the image, then the first area to be cut will expose this.
- This first cut area can then be inked in the initial colour of choice and printed once only to produce a monoprint.
- Following cuts and incisions will expose all printed areas in the inked colours previously used.
- Continue cutting and printing in this way until image is complete.

Unique finishing techniques for relief printing

Relief monoprints can easily be produced by a variety of additions to finished prints, such as using hand-colouring, collage or added texture.

Carborundum or sand

This method is similar to aquatint (see Chapter 6) because it creates a block with surface texture of various grades of grain to hold ink. To make monoprints using this method you must take a strong base block of metal, wood, plastic or card and draw the desired image with PVA™ glue or polymer medium. Pour either carborundum or sand (of a chosen grade) onto the still wet glue and wait for it to dry. Then remove the surplus by tapping the block or brushing the excess onto newsprint to remove any grit. Store this residue in a container for further use. What is left on your block is a surface that can be either intaglio inked, wiped and printed or top/relief rolled (or a combination).

For a variety of surfaces, coffee grains, pepper grains, tea-leaves, wood and pencil shavings, nut shells and graphite can be used. However, these must be well adhered to the board as they are softer than the conventional materials and more vulnerable to pressure. Once applied and dried, the surface should be sealed with

▲ Dee Whittington, *Mono Lisa*, 2003, 19 × 28 cm (7 × 11 in.). Lino cut, using process colours: cyan, magenta and yellow.

▼ Katie Clemson, *Mad Red Fly* and *Fleeting Fly*, 2002, 55 × 74 cm (22 × 30 in.). The author prepared and printed the blocks and then applied hand-colouring in her lino cuts. She also used other materials such as charcoal, ink, gold-leaf, pastel on *chine collé* (Japanese tissue) on Fabriano watercolour paper.

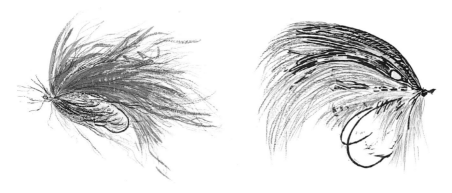

◀ Anne Gilman, *Your Trips Away From Me* (*2 Yellow Vases*) (Panel 8), 1999. This work is part of a larger piece comprising many panels whose total size is 140 × 110 cm (52 × 40 in.). The artist used woodblock onto canvas. These relief blocks were printed in black, and covered with various stains of colour.

▶ Anita Klein, *A Book on the Beach*, 2003, 60 × 40 cm (24 × 16 in.). The artist used carborundum, watercolour, special papers and collage.

varnish, either button polish or yachting varnish as both dry quickly. Shellac is also a suitable choice but takes longer to dry. All solvents should be applied in a well-ventilated area. If a card block is used, varnish should be painted on the reverse to ensure it is totally waterproof.

The carborundum method has also been used by Howard Jeffs, where he mixes carborundum grains with glue in a small pot and applies this paste directly to the plate, rather than pouring the grain onto the areas where adhesive has been applied. This gives a less intense tonal result because a reduced amount of ink is retained.

▶ Howard Jeffs, *Cinabar*, 2002, 40 × 30 cm (16 × 12 in.).

▼ Howard Jeffs, *Yellow Tale*, 2002, 30 × 40 cm (12 × 16 in.).

◀ Jane Stobart, *Evening*, 2004, 60 × 50 cm (24 × 32 in.).

Jane Stobart's *Evening* is a print based on a drawing carried out at the Whitechapel Bell Foundry, London. The print comprises two print runs. The base blue-grey colour was printed by inking-up a piece of cardboard and running it though an etching press onto a sheet of dry Somerset paper. The second print was the bell-top image which was created by painting wood glue onto an aluminium plate. As in the conventional method, the wet glue was then sprinkled with coarse carborundum grit. When dried the entire plate was inked with a roller using white relief ink, and printed over the first print in base blue-grey. Some areas at the top of the bell cannon image have been wiped clean of ink with a rag-covered finger to reveal blue when printed. This image was not printed as an edition, and is therefore a monoprint.

Collagraph

Collagraphs are wonderful for creating rich textures, marks and patterns. They are a versatile and inventive form of printmaking and the medium offers seemingly boundless possibilities for artists to add and remove surface areas.

◀ Diane Miller, *Cloudscape*, 65 × 50 cm (26 × 20 in.). Oil- and water-based inks were used with collage and then printed on silk tissue.

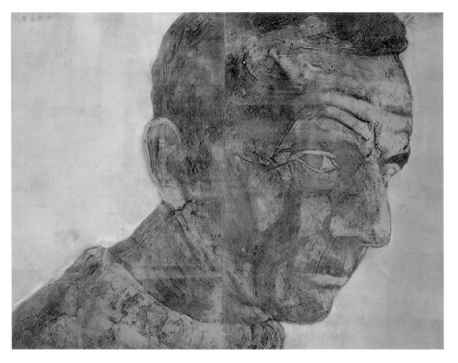

▲ Cameron Fraser, *Brian the Book*, 2001, 120 × 90 cm (48 × 36 in.). In this image the artist has used two runs and three colours.

Materials are fixed to a surface such as card, plastic or metal, after which the block must be fully sealed by applying at least two coats of varnish to either side. The first coat must be allowed to dry before the second application. This ensures that it is protected and durable for printing. Collagraph is an economical process, because it utilises discarded materials and found objects. The cheap availability of a wide variety of materials encourages many artists to use this style of working.

It is not necessary to use a press in the collagraph printing process, a fact demonstrated by Matthew Meadows, who co-ordinates workshops where little or no equipment is available, (such as outreach projects in schools, hospitals and prisons). He gave a recent monoprint workshop resulting in the production of prints which made use of discarded packaging materials. This suited the 'use everything' logic of institutional economies.

In workshops conducted in institutions like hospitals or prisons, time and space are paramount as there are no storage facilities. Meadows therefore has had to devise quick and easy solutions, such as using Pritt Stick™ and double sided tape to stick textured materials, like wallpaper and laminated cereal boxes, to the baseboards. Owing to financial and time restraints boards are not sealed with varnish, which means that the blocks are not durable, therefore making editioned print runs impossible. However, the results are highly successful.

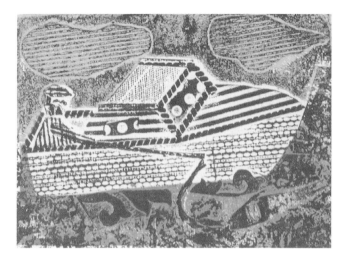

THIS PAGE AND FACING PAGE; illustrations of work from Matthew Meadows' project with the Art-Alive Trust.

Technique for making monoprint collagraphs without a press

This simple process is as follows:

- Plate building: use double sided tape on sturdy card and apply it to the entire surface of the block.
- Arrange selected pre-cut shapes of varying textures and materials and place them onto the sticky surface. Additional shapes can be added by using Pritt Stick™.
- When making monoprints there is no need to seal them with varnish on completion. However, if more time is available PVA™ glue is preferable, not only to stick textures, but to create them and to act as a sealant when dry. PVA™ must be allowed to dry completely before printing.

- Paper: for this method heavy printmaking paper is essential. Meadows recommends the very economic Magnani Acqueforte 310 gsm from John Purcell Paper.
- To prevent transferring inky fingerprints to the paper, it is advised that 'paper picks' are used when handling printing papers. These are simply two small pieces of folded printing paper held between finger and thumb at diagonal corners when lifting the paper.

◀ Detail from a collagraph by Daphne Casdagli.

- Inks and inking-up: water-based inks are best to use in all studios, whether private or public. Matthew Meadows recommends Berol™ printing emulsion (waterproof) or NES Arnold multi-print inks.
- Printing: it is possible to print several colours simultaneously, using a technique loosely based on the famous printer Stanley William Hayter's double viscosity, multicolour etching method. Generally you should ink up light to dark (although this very much depends on the quality/ opacity of the ink); lighter colours go into the plate with a soft roller, then progressively darker colours are top rolled with a hard roller. This ensures that all the inked areas of the block are printed.
- When working individually, as well as with teaching a group, it is advisable to make certain preparations in advance, for example, registration (see Chapter 2) to ensure that each print is registered correctly and will produce a precise, clean border.
- Place the inked block onto the designated area.
- Take the pre-dampened, blotted printing paper and place it over the block, in the marked area.
- Now back this with newsprint and, using a wooden spoon or a baren (either Japanese or mechanical), apply pressure by rubbing the paper, taking special care not to cause the paper to slip. This action transfers the image from the block to the paper.
- In the event of over-inking the block, it may be necessary to lay newsprint onto the wet print and rub lightly to remove the excess. This latter action is known as stripping.

The various types of marks and textures that can be achieved using this medium are evident in the details shown by the work of Richard Russell (see page 64) and Daphne Casdagli.

Another good example of a collagraph is *Germinal* by David Jarvis, where the artist has made use of natural materials, including corn on the cob skins

▶ David Jarvis,
Germinal, 1999, 64 × 46
cm (26 × 18 in.).

▼ Trevor Price, *One
Hundred and Seventy
Four Days of Summer*,
2003, 76 × 100 cm
(30 × 40 in.).

and cabbage leaves for texture. These were printed as intaglio, then overlaid
with inked string and printed in relief. In total, five different layers were used
to create this print, each one being thoroughly dry before the next run. The
fact that the artist has added string in an arbitrary manner to his composition,
plus the inclusion of the painterly monotype technique, means that it is a
unique work and cannot be repeated.

In the work by Trevor Price, *One Hundred and Seventy Four Days of Summer*,
the artist has produced a monoprint combining inventive methods as follows:

- Price first produced a monotype, using a plate that is larger than the paper to create a bleed print (see Chapter 2).
- On this he applied many different colours to produce the first print.
- When fully dried he repeated the process. This time the artist used torn tissue as a resist stencil, which he placed on to the block before printing again.
- On the following print run he reversed and recycled the same tissue stencil, which contained ink, and placed it ink side up on the block to build both shape and colour.
- In the production of the collagraph element of this print, the artist selected a steel plate onto which he applied a mixture of Polyfilla™ and PVA™ glue to create form and pattern. He used this mix because Polyfilla™ alone is likely to crack and glue is less substantial.
- He then took another plate, which he pressed to the glued surface of the original plate, and manually pressed together for a few seconds. On removal a texture was evident.
- Whilst the mixture was still malleable the artist worked on the surface to construct the composition of the block.
- When thoroughly dry he then sanded the surface to remove any unwanted peaks.
- Next the artist relief rolled the block using white ink without transparency added.
- Using a final stencil of tissue paper, he applied this to a selected area of the block to act as a resist and allowed the colours from the original monotype to show through.

Trevor Price's process of working affords many exciting opportunities for the artist to experiment with combinations of other media as well.

In Jackie Newell's *Inscriptions*, the block was constructed using card and gesso was applied. Both coarse and fine carborundum were added to the wet gesso to add more texture and give an eroded, decaying effect. The block was the same size as the A0 Somerset paper on which it was printed. The printing was a combination of many individual monotypes on Perspex™, interspersed with collagraph block printing using both intaglio and relief methods.

▲ ◀ Jackie Newell, *Inscriptions*, 1998, (detail, left); 110 × 75 cm (44 × 30 in.). The artist used a combination of nearly all printmaking techniques: collagraph with carborundum, lithography, lithographic rubbing, stencils of tissue paper, gesso (acrylic polymer) were all added. It was printed in intaglio and relief and finally finished in graphite dust.

It incorporated stencils of torn tissue paper to create irregular shapes exposing selected underlining areas. The paper was printed many times, building up numerous layers of colour using lithographic oil-based ink including large amounts of extender base. Due to the many printings, the texture of the paper changed, becoming leathery in appearance as a result of the amount of ink used.

A lithographic plate was made from transfer paper taken from the rubbing of an ancient tombstone in Devizes Church. This key plate was then intaglio rolled and printed using extender base. The work was then finished with graphite dust which adhered to the wet clear ink used in this process. The combination of all these techniques created a unique print.

This chapter has introduced a range of basic, intermediate and advanced processes which, dependent on the artist (and work), can be combined successfully as described.

▲ Detail from collagraph by Richard Russell.

5 ■ SCREENPRINTING: EASY SQUEEGEE

Screenprinting is a simple and fun method of printing. Its broad appeal is open to a wide audience of artists who work in almost every style, from hard edge or expressionist abstraction, through to traditional compositional studies. The most exciting aspect of screenprinting is the many possibilities it offers, making it particularly useful for monoprinting. One of its advantages is that many materials can be used on a variety of surfaces. As an extravagant example, Andy Warhol famously used diamond dust in some of his screenprint images.

In general terms, screenprinting is a method of producing prints by passing ink through a mesh using a rubber squeegee. Only one colour is applied during each printing, although blends of various colours are sometimes used. The screen mesh (which was once silk but is now a synthetic substitute) is held taut by its adhesion to a wood or metal stretcher, which usually has a stencil or mask applied to it and is excellent for printing broad, flat areas of colour.

Screenprinting is also a direct medium owing to the fact that it does not print in reverse, unlike the traditional mediums of etching, relief and stone or plate litho. In addition to these positive aspects is the fact that a press is not

▲ Donna Moran, *2nd Mythology Variation*, 1994, 68 × 100 cm (27 × 40 in.), silkscreen acrylic on paper plus additional hand-colouring. This is an excellent example of the capacity of this medium to enhance strong composition with bold colours.

necessary, only a frame (preferably aluminium) of stretched mesh, a rubber squeegee, ink and a simple stencil are required to start work. These items are all available from good art supplies stores.

Artists have benefited from the industrial use of this medium, the history of which can be traced back through the ages, although the earliest industrial patent for this process was made to Samuel Simon, Manchester, England in 1907.

Industry happily employed the tremendous reprographic possibilities offered by screenprinting, and when it became aware that health and safety measures were urgently required, many improvements and necessary developments were made to the materials used for this process. Due to these measures, photographic stencils are now more commonly used in conjunction with water-based screen inks. However, oil-based inks are still available and offer a wide choice of colours and types of ink (i.e. fluorescent, metallic), but manufacturers are working hard to increase the range of water-based inks for retail. If oil-based ink is chosen for printing, always read and follow the manufacturer's advice.

The open screen technique

A simple method of producing a mono screenprint is to paint directly onto the screen and pull the ink through the mesh onto paper. This is called the 'open screen' technique and was used by Janet Brooke in *The Gas Works Again*.

This technique is as follows:

- Degrease both sides of the screen with detergent/washing up liquid and apply water with a soft brush and allow to thoroughly dry.
- A seal must be made between the edges of the mesh and the frame, for protection and easy cleaning. Fix the inside screen edges with brown, plastic parcel tape, allowing at least a 10-12 cm (4-5 in.) border between the screen and the area for printing.
- Set up the printing area. Ensure that it is a clean, flat and even surface.
- Lay a dry sheet of paper (200 gsm minimum) underneath the screen.
- The screen has two sides, these

◀ The printing side of a screen.

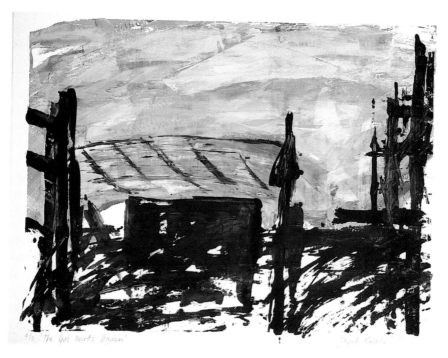

▲ Janet Brooke, *The Gas Works Again*, 1990, 77 × 60 cm (31 × 24 in.).

are called the flat side and the printing side. The flat side is to be laid directly over the paper, the printing side (with the frame) is to be uppermost.

- If using a press, screw the screen into position. If printing without a press, attach four 0.5 cm (¼ in.) blocks (minimum) to the flush side of the screen at its corners. Add more blocks if the screen is large. This is to provide a distance between the surface of the screen and the paper and is called 'snap', which prevents the paper from adhering to the screen after printing.
- It is important to have a stable base on which to print, otherwise movement will occur and cause a blurred image.
- Prepare the artwork by painting directly onto the open screen, using as many colours as required, with paintbrushes, fingers, cloths and any other items to aid image completion.
- Ensure the consistency of the ink is similar to that of double cream, i.e. neither too runny nor too thick, as the former will run through the mesh and the latter will clog the screen. It is important to note that a little ink goes a long way. Therefore, it is advisable to pour a small amount into a cup and mix slowly with water. If oil-based inks are used, the same applies, except mix with turpentine or white spirit.
- When the image is complete, take a squeegee which fits within the frame and is also at least 5 cm (2 in.) wider than the width of the image, thus allowing an additional one inch either side for successful printing.

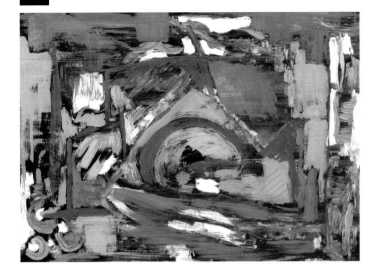

◀ Gillian Best Powell, *River Night Lights*, 2002, open screen technique, 85 × 61 cm (34 × 24 in.).

- Pull the squeegee across the screen, pushing the ink through the mesh evenly onto the paper below.
- Immediately after the printing process, lift the screen upwards and away, to observe the result and remove the screen from the paper.
- This process can be repeated on the same image, but the ink must be dry before reprinting.
- It is advisable to clean the screen soon after printing, as ink dries quickly and becomes difficult to remove. To clean the screen, remove the residual ink with small pieces of cardboard and retain, as this ink can be reused.
- Wash the screen with water if using water-based inks, or relevant solvents if using oil-based inks.

Screenprint presses

Screenprint presses range from the self-build models, which can produce good results at a fraction of the cost of purpose built presses, to sophisticated commercial presses. Gillian Best Powell's press was specifically designed and built by her artist husband Glyn Powell for economy, convenience and transportation. This made possible her working relocation to Dubai and subsequent return to London, as the press is so easily dismantled.

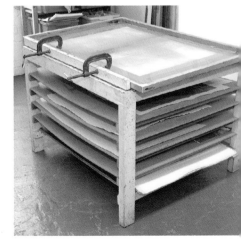

▲ Gillian Best Powell's press.

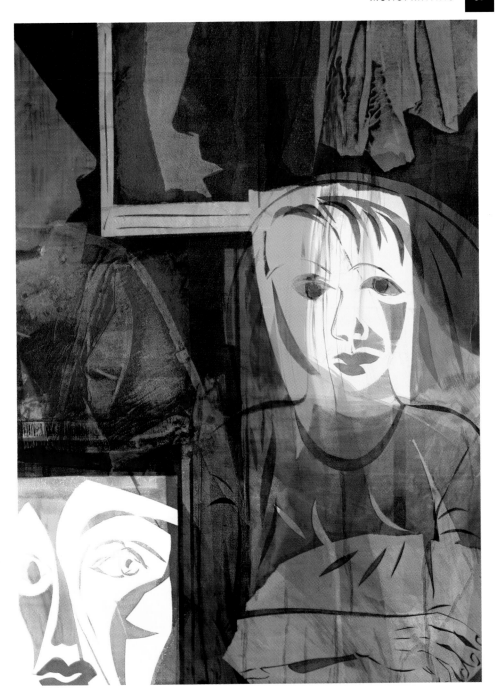

▲ Gillian Best Powell, *Teenage Angst*, 2004, 85 × 62 cm (34 × 24 in.). The artist used a different technique of carefully cutting stencils, using a scalpel, out of clean newsprint (readers should be careful not to confuse this with newspaper, as this is printed and dirty with ink). The finished result took many print runs.

Best Powell's work concentrates on the production of monoprints, their content reflecting her interest in colour and texture. The artist admits to enjoying the process of obtaining images and juxtaposing them in unusual ways. She sometimes uses bulky items (flowers, etc.) as stencils and uses the following process:

- She places the flower stencil on the paper, under the screen.
- A ribbon of ink (the same width as the squeegee) is spread across one end of the screen.
- The squeegee is pulled through the ink reservoir across the screen, to deposit the ink on the paper below.
- A negative un-inked shape is revealed on the paper when the screen and plant-stencil are removed.

The artist works in multi-layers, printing over and over again but always leaving the print to dry thoroughly prior to reprinting. She chooses to print on 300 gsm Somerset Satin paper and favours the water-based *Lascaux* screenprinting system, where the pigments are mixed with screenprint paste, which comes either as a transparent or opaque base.

The artist Dee Whittington uses a commercial screenpress, purchased in 1986 when she established her studio Design Ink in Spitalfields, London. The press was manufactured by Winton, who are no longer in business. However, Patrick Pace, the designer of the Winton press, now works at a similar company called Screenmachinery. Commercial screenpresses have useful additions such as vacuum beds that use suction, powered electrically, to hold paper *in situ* whilst printing. They also offer advantages such as the one-arm printer, which holds the squeegee so that it can distribute evenly the required amount of ink through the screen-mesh onto the paper below.

▲ The Winton press.

Stencils

As already illustrated in this chapter, there are various techniques used in the making of screenprints. These include stencils (basic mask method), painting the screen with inks (open screen method), drawing on the screen with watercolour, poster paint or gouache and afterwards applying necessary solutions to transfer the former materials to paper. Photographic stencils are now extremely popular, and compatible with water based inks.

Photographic stencils do not necessarily mean the use of a photographic image, but refer instead to original artwork being transferred to the screen by exposing an image onto a light sensitive emulsion. Procedures for coating and exposing screens are detailed below, but these are only general guides because studios, institutions and workshops vary both in the equipment they provide and the materials they use.

▲ Dee Whittington, *Bass Duet*, from *Cathedrals of the City* suite, 1994, 28 × 38 cm (11 × 15 in.). Photographic and hand-cut stencils were made from constructed artwork. Black water-based ink was printed first, and later oil-based silver ink was added. Silver ink was also loosely applied by hand as a final element.

Coating

- A generous amount of light sensitive emulsion should be poured into a trough that is larger than the image size (a trough is a V-shaped metal instrument that holds the light sensitive liquid).
- Lean the clean and degreased screen securely at a slight angle (i.e. against a wall or workbench) with its flat side facing you, for application.
- Start from the bottom of the screen, rest the trough on the mesh, tilt the trough to allow the emulsion to contact the mesh and carefully pull the trough up the screen. Ensure at all times that an even pressure is applied throughout this action.
- Do not let the trough touch the frame edges of the screen as pressure cannot be controlled here, and this could cause a thick coating to be left, which must be avoided as it creates problems later in printing.
- When the emulsion has been pulled across the surface, return any excess emulsion to its container.

- Remove any excess emulsion from the screen. Use a card to scrape off any heavy deposits, and return this to the emulsion container for reuse.
- Leave the screen to dry, or preferably place into a dryer if available.
- Wash and clean the trough, plus any other items used during the process.

The following stage is for artwork to be exposed onto the screen by use of an ultra violet (UV) lightbox. The basic principle is that UV light passes through the transparent, non-printing areas of the image and this action hardens the emulsion and creates the stencil.

Exposure
- Do not place the image to be exposed too near the frame of the screen, as this area will not print.
- If exposing several stencils on one screen, allow enough space around each to:
 – provide room for the ink reservoir at both ends.
 – easily allow for blocking out stencils that are not to be printed.
- Clean the glass of the UV lightbox thoroughly, removing any dirt or marks (these will otherwise be exposed onto the artwork).
- Secure the artwork to the flat side of the screen (using the minimum amount of adhesive tape as this will also show up as a shape on the exposed stencil).
- Place the screen face down, (i.e. flat side down), onto the upward facing artwork and arrange both on the glass in the centre of the UV lightbox.
- Proceed to use the UV system to the manufacturer's recommendations. These vary at different institutions and workshops. Advice must be sought on individual machines.
- When the screen has been fully exposed correctly, detach artwork and then remove and rinse/hose away with water any residue emulsion from both sides of the screen.
- The screen should now clearly show the image for printing with all the unhardened areas of the image removed.
- On a clean table, blot the mesh with newsprint to remove excess water and dry the screen for printing.

American artist Debra L Arter, a member of the Boston Printmakers, has also successfully combined various media with collage in *Chancel Theme*. This is now in the collection of the First Presbyterian Church of Whitestone NY, USA. The print is a monotype with screenprinting and *chine collé*.
 The process she used is as follows:
- Newsprint was torn randomly to make the paper stencil fit under the silkscreen mesh.
- Several colours of water-based inks were used, including red, using the screenprinting process.
- After the initial images had dried, the artist painted with oil-based inks, onto Plexiglass™, which she used as a matrix to create a monotype.

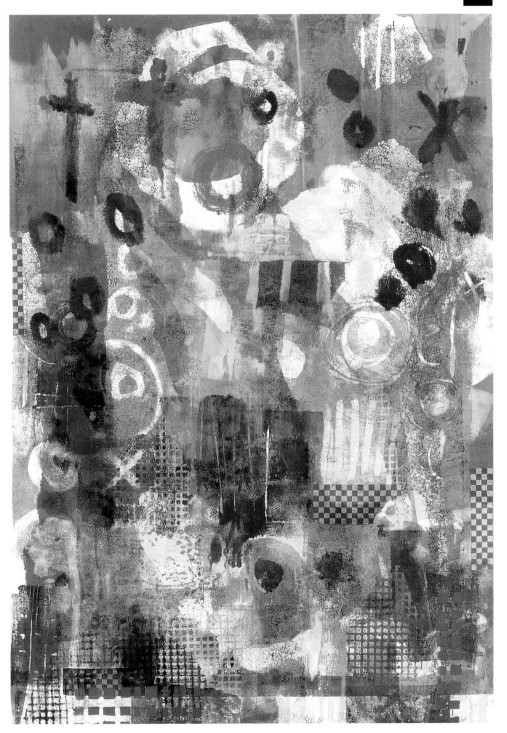

▲ Debra L Arter, *Chancel Theme*, 1998 – 1999, 57 × 53 cm (26¼ × 21 in.).

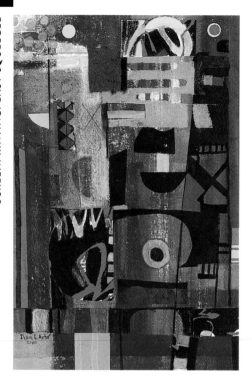

◀ Debra L Arter, *Harbor Lights*, 2001, 22 × 15 cm (8½ × 5¾ in.).

- She used both brayers and brushes to create the monotype image and blocked out parts of the print with tissue, mesh and dollies.
- At this stage she added some bits of Asian metallic paper in the *chine collé* manner and collaged them to the print.
- The monotype was then printed over the original screenprint.
- She completed the image by reprinting in several places with thinned inks and Q-tips to remove parts of design (blue areas).

In *Harbor Lights*, the same artist used ordinary newsprint that she cut into random shapes with an X-acto blade. She fixed these to the silkscreen mesh on the underside of the screen (flat side) with water-based inks. Acetate was used as a test print and later as a registration guide for the paper.

Using the 'open screen' method, the artist used several colours of ink together in the first print run and allowed this layer to dry before repeating the process with a different matrix using other colours. She printed the new image on acetate, and used this as a guide for the development of ideas and composition. At this stage she added some collage papers to the print.

When near completion, a layer of ink mixed with a portion of transparent base was printed to lightly obscure some elements and enhance

◀ Diane Miller, *Haiku II*, 2002, 55 × 37 cm (22 × 15 in.).

▲ Janet Brooke, *Crossing Wellington Street*, (left) 2002, and *The Big Red Truck*, 2001. Both prints are 55 × 75 cm (22 × 30 in.) and began as monotypes using oil-based relief ink. They were then screenprinted using the photographic stencil technique with water-based ink.

the blue tones. Finally, coloured pencil and more collage (from previous silkscreen prints) were added to complete the monoprint.

Diane Miller, a multimedia printmaking artist, uses various combinations of printed materials. In *Haiku II* the background is a monotype made with bronze metallic ink, overlaid with some fragments of other monoprints (printed on thin Japanese paper) to which collage has been added. A photographic stencil of a circle of tree branches was screenprinted onto the collaged monotype. A further collage of intaglio and monotype fragments was applied to the screen circle. This sensitive and delicate print evokes an oriental quality, not normally associated with the medium of screenprinting.

Screen registration

Registration is critical (even in monoprints) for correct placement of added elements. A standard and easy procedure for screen registration is as follows:
- Take a clean sheet of appropriately sized acetate, i.e. larger than the print.
- Fix it securely to the press bed (or printing area) with masking tape at the top or side.

◀ Phoebe Shin, *Reflection 1*, 2002, 84 × 104 cm (33 × 42 in.). The artist used colour separation and printed in water-based ink. The separations were applied to screens as four separate images using the photographic stencil technique. Accurate registration was necessary in the print runs to produce the final image.

- Print the trial run onto this sheet.
- This acetate can then be flipped back to allow for printing paper to be placed in the correct position.
- Remember to remove the acetate prior to printing!

Colour separation

Colour separation is very popular in screenprinting (as well as being widely used in other printing methods). A colour separation is created when an image is converted (using a computer programme such as Adobe Photoshop™) to CMYK mode. The colours in the CMYK image are separated for printing into the four process-colour channels: cyan, magenta, yellow and black. An RGB image has three colour channels: red, green and blue and is the mode used for working digitally, either directly on a PC screen or for producing work to be seen on PC screens, such as website design or visuals for CDs.

◀ Joseph A. Osina, *Elements (with water)*, 2002, 14 × 13 cm (5½ × 5¼ in.). The artist made silkscreen monotypes using oil-based ink. This illustration shows one double page from the accordian book. Calligraphy was applied to the inside leaf of the box.

▲ Dale Devereux Barker, *No Problemo*, 2000, 76 × 52 cm (30 × 21 in.). The artist used six colours in silkscreen.

On-screen images are prepared for print by following the requisite steps for reproducing colour accurately, and converting the image from RGB mode to CMYK mode to build a colour separation. Should artists not have access to Adobe Photoshop™ to create this separation themselves, they should seek out high street print bureaus or specialist print studios where this procedure can be completed at a cost dependent on the size of work required.

Screenprinting brings to mind bright, bold, flat colours and shapes. However, screenprints are not always like this, as the addition of textures and materials can produce wide variations. This enjoyable process is available to all ages and abilities, offering fun and the opportunity to experiment.

6 ▪ THE TRADITIONAL PROCESSES: HIDDEN DEPTHS AND SENSUOUS SURFACES

■ The traditional etching (intaglio) and lithographic processes can be applied to monoprinting. These methods are briefly described in the following examples using artists' work as illustrations.

Etching (*intaglio*)

Intaglio is derived from the Italian word *intagliare* which means to cut in. Intaglio suggests an editioned print using incised plates or blocks. This is not necessarily the case as intaglio offers wide scope in monoprinting, traditionally by the use of hand-colouring using brush and watercolour post-printing.

The basic principle of etching is to create marks below the plate surface, with a view to their holding ink, the surplus of which is wiped away so that the ink remains only in the incised areas. The ink is transferred to dampened paper in the printing process by using soft press blankets and extreme pressure from the etching press.

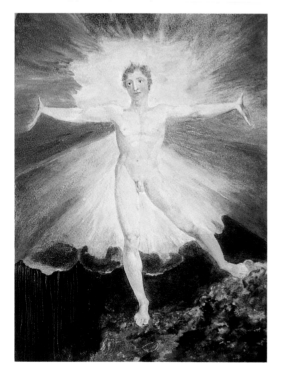

Intaglio methods

■ AQUATINT: In the aquatint process, resin dust is applied to a degreased plate and fused with heat, which creates dots of resin that are resistant to acid. The tiny exposed areas are etched in acid and subsequently hold ink, which is transferred as tonal gradients in the print.

◀ William Blake, *Albion Rose*, 1796, 27 × 19 cm (11 × 7 in.). The artist produced a coloured printed etching with hand-drawn additions in ink and watercolour. Although Blake used an etched matrix, which could easily be editioned, the fact that he added ink and watercolour by hand made it a unique print.

▶ Jackie Newell, *Window Series*, 2001, 75 × 55 cm (30 × 22 in.). The artist used *chine collé* and aquatint.

■ *A LA POUPÉE*: Intaglio monoprints can also be made by the *a la poupée* method, which means colouring sections of the plate prior to printing. This term describes the small strips of tightly rolled felt blanket used to distribute separate coloured inks to individual areas on a single plate. Intaglio monoprints can also be combined with other printmaking disciplines (relief, screen and litho) to create unique prints.

■ SUGAR LIFT: The term sugar lift generally describes a mixture of water, sugar and India ink which is applied to a clean, degreased plate with a painting brush. When dry, the plate is coated with a resist called liquid hard-ground and allowed to harden. It is then placed into a tray of hot water and the sugar lift area should be gently rubbed with either a brush, cotton bud or finger. This action will expose the metal in the desired area, whilst the hard-ground will protect the remaining plate. Resin dust is then applied (by hand or resin-box) to the open metal, fused with heat, as in the aquatint process, and bitten in acid for the designated time.

◀ Grey scales showing times for aquatints and etching.

◄ Dee Whittington, *Urban Interchange*, 75 × 75 cm (30 × 30 in.) (4-part plate). The artist used *chine collé* and aquatint to achieve tonal qualities.

■ SOLAR PLATE: The style of etching called solar plate was discovered by Dan Welden. The process involves drawing or painting onto a transparent film, which is placed image side down onto the surface of light-sensitive polymer plate (emulsion to emulsion). This is then sandwiched (with good contact) between two pieces of glass, which are then exposed in the sun. Wherever ultraviolet light strikes the surface of the plate, the polymer hardens, while parts of the polymer blocked from the light remain soluble in water. This soluble residue can be washed away by gentle scrubbing in tap water, leaving the plate with lines and grooves seemingly etched in the polymer. The plate can then be inked in intaglio or top-rolled with ink to create a relief print.

In *Window Series*, Jackie Newell used the following *chine collé* process to produce her monoprint:

• A 16-gauge copper plate was cleaned and degreased.
• A design was painted onto the surface with lithographic *tusche* mixed with water and methylated spirits for a 'wash' effect and allowed to dry.
• Resin was applied from an aquatint box onto the etching plate and fused using a hotplate at high temperature.
• The plate was backed with acid resistant plastic and immersed in a bath of 22% *beaumé* ferric chloride for 20-25 minutes, during which period the bath was gently rocked to remove any sediment.
• The plate was removed from the bath and rinsed well prior to dissolving the resin with methylated spirits, followed by white spirit or turpentine to clean away the lithographic *tusche*.
• The plate was prepared for printing with Charbonnel etching ink and then placed on a press-bed.

▲ Lisa Milroy, *New York Street (6)*, 1999, 77.4 × 154.7 cm (31 × 62 in.). The artist hand inked the etching and added collage. Reproduced courtesy of Alan Cristea Gallery, London.

- Then the artist used Nepalese coloured paper, pre-cut into various shapes, the smaller of which was placed down first onto the inked plate and brushed with acid-free paste (wallpaper paste or methylan cellulose). This process was repeated several times until a paste consistency similar to runny honey was achieved.
- Pre-soaked Somerset Textured white paper was placed over the prepared plate and printed using an intaglio press.

The etching press

The intaglio printing method cannot be achieved without a press, so it is certainly recommended that keen amateurs locate a good print workshop which would offer etching facilities and supervision.

The etching process uses metal plates, e.g. copper, zinc and steel. The preferred metal of the authors is copper, because it can be etched in a dilute solution of ferric chloride, (which is a salt) rather than an acid such as nitric or Dutch mordant. This choice is also recommended for health and safety reasons because it is less hazardous in its use and storage. This material is sold in volumes of full strength 42 *beaumé* from specialist suppliers and needs to be diluted with water 1 to 1, to half strength, i.e. 21 *beaumé*. Unlike mixing nitric acid, it is perfectly safe to add water to the solution when mixing. Using a hydrometer (also available from specialist suppliers) the correct mixture is easily measured and should be frequently monitored as the water evaporates when left uncovered, reducing the solution to a more concentrated mixture. The evaporation also causes the materials to be airborne resulting in erosion of nearby metal, so a ventilation fan is necessary. For this reason it is advisable to

◀ Hunter-Penrose Littlejohn etching press.

▼ Offset litho press at Alan Cox's studio 'Sky Editions'.

cover the acid tray whenever possible and to return the entire solution to a screw top container for storage (when the etching is completed) and keep this in a secure cabinet. Protective clothing must be worn and care taken, due to the staining quality of this substance. Any spillages should be cleaned immediately with water and detergent followed by a mixture of salt and cider vinegar.

More examples of intaglio monoprinting are shown on the following pages.

▲ Anne Gilman, *Vase without Text*, (a panel extracted from a larger work comprising many panels), total size 130 × 100 cm (52 × 40 in.). The artist used a copper intaglio plate and a variety of traditional etching processes, including tonal washes, aquatint, dry-point, scraping and burnishing. The plate was wiped arbitrarily to create a monoprint.

▲ (right) Anne Gilman, *Your trips away from me*, (detail from Panel 3). The artist has created an exciting monoprint by wiping an intaglio plate using black ink, then reworking by hand, adding shades of red. This print was then mounted onto canvas and further developed with staining and wiping, treating the canvas surface as though it was the plate itself. Since the printed paper was fixed to the canvas, the process can be likened to *chine collé*.

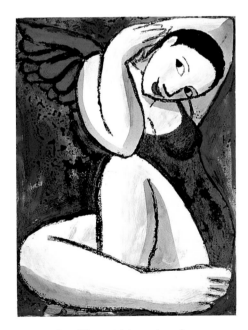

▶ Anita Klein, *Red Angel Doing her Hair*, 2003, 42 × 31 cm (17 × 12 in.). The artist has combined an etching plate process with sugar lift aquatint and then applied watercolour. The print is made unique by adding the watercolour by hand and choosing not to repeat colour combinations.

◀ Wendy Dison, *Florence as I was*, 2003, 36 × 30 cm (15 × 12 in.). The artist used oil-based etching inks rolled onto a Plexiglass™ or Perspex™ plate wiped with cloths, drawn into with a paintbrush handle and relief printed with corrugated card. This was then transferred using a press onto dry paper. The next stage involved soaking the paper briefly in water before printing a solar etched plate in an intaglio style, over the monotype. The cross, the line at the bottom edge and the 'shutter' motif (on the right of the image) are the result of the solar plate.

◀ Diane Miller, *Night Branches*, 29 × 29 cm (11½ × 11½ in.). Here the author combines collage with etching. She admits to being highly experimental and uses many different kinds of paper, some of which are made by herself. Often she prints up to seven sheets of exceptionally thin paper in one run. The ink bleeds through these sheets, the papers closest to the inked plate printing darker, whilst those nearer the blanket pick up less ink. She makes several prints from an etched plate and stores these papers for future use. This method would not be suitable for an edition, but in creating a monoprint the wide variety of tonal ranges and subtle nuances are perfect. The finished effect is one that is translucent and textured.

▶ Jackie Newell, *Gold Window*, 2001, 38 x 21 cm (11 x 7½ in.). A deeply bitten plate was produced using lithographic crayon as a resist to the effects of ferric chloride. This created textures and layers of varying depths. First the plate was inked intaglio style with black etching ink pushed into the textured areas, then the surface area was wiped clean. Bronzing dust was mixed into a smooth, loose paste consistency and this was then top rolled onto the surface with a soft roller, an action which also reached some of the under-bitten areas. Although results can be similar with each printing the artist deliberately utilised the arbitrary nature of this process so that no two prints are identical and therefore each one is unique.

▶ (below) Dee Whittington, *Castelli in Aria*, 2003, 20 x 15 cm (8 x 6 in.). In this print, the imagery unites Leonardo da Vinci's *Mona Lisa* and Michelangelo's *Giuliano de Medici*. This work was inspired by art history, as Medici was one of Leonardo's patrons and it has been suggested the former requested a portrait be made of his mistress. If true, this could be the answer to the mysterious identity of the lady with the enigmatic smile. The architectural elements relate to St Lorenzo in Florence, with particular reference to its Medici chapels.

The design for *Castelli in Aria* was manipulated digitally, using Adobe Photoshop™. The result was then processed as a photographic etching onto a 16 gauge copper plate, which was then degreased and coated with resin, fused to the plate and bitten in ferric chloride for the requisite time. It was carefully monitored to prevent the aquatint over-biting, a term referring to the accidental removal of resin when the plate is left too long in the acid bath. Charbonnel black ink and a Littlejohn etching press were used in the printing. A small edition of these prints was made, and each individually painted by hand to make the works unique.

Lithography

The gestural and tactile nature of lithography appeals to many painters who favour this method of printmaking. Characteristic of this process is the vast range of exciting marks and textures, offering enormous potential for expression. Lithography differs from other printmaking processes as it depends on a chemical reaction based on the antipathy of grease and water. This process is performed on either limestones or manufactured plates made from zinc or aluminium with simulated surfaces that resemble the natural surface of the lithographic stone.

Lithography is a complex printmaking process requiring specialised equipment and workshop facilities, which are not always easily accessible. However, there are certain open studio/workshops available that offer access to those interested in pursuing this area of printmaking.

The basic lithographic preparation process
(NB: These instructions are only for use in professional workshops under supervision)
- Take a prepared litho stone or plate.
- Paint a 5 cm (2 in.) border with gum Arabic and spread it thinly. Hold the brush flat for a straight edge.
- Draw a guide image onto surface with either *conté* pastel or charcoal.
- Select a suitable medium, i.e. litho crayons, pencils and *tusche* to create the image.
- Measure 1 ounce of gum Arabic with approximately 12-16 drops of nitric acid. This is to change the surface of the stone from one that holds grease, to one that repels it.
- Sprinkle rosin onto the stone or plate; move it around taking care not to erase the drawing, then leave it there.
- Sprinkle French chalk or baby talc onto the stone or plate.
- Mix the solution of gum Arabic and test it on part of the plate or stone to see the reaction. It should be slightly effervescent, but not too much.
- Ensure that three wads of cheese cloth or muslin are ready for use.
- Brush on the solution and spread it over the surface. Remove any excess.
- Leave for 2 minutes.
- Buff down the surface very well with the cheese cloth or muslin. This remains as an absorbed film on the stone or plate.
- Keep the plate or the stone away from water and store it for 2-20 hours to thoroughly dry. Should any water get onto the surface, take a little gum solution and buff it down again.

The basic lithographic inking and printing process
- After the drying period the stone or plate is ready for rolling up with ink.
- It is advisable to use a leather roller when using black ink. This must be

▲ Jackie Newell, *Graven Fragments*, 2001, 55 × 75 cm (22 × 30 in.). The block was constructed out of card with moulding paste and carborundum to create a surface reminiscent of a weathered architectural fascia. A combination of completed lithographic prints and a collagraph block were the basis for this piece; the lithographic prints were randomly torn and loosely assembled to decide a structure for the composition. These were placed image face down onto the inked surface and treated as in the *chine collé* method (see Chapter 6) and stuck to a sheet of Indian Khadi paper using an etching press. The highly textured collagraph was inked with oil-based sepia and graphite etching ink mixed with a substantial amount of transparent base, to allow the collaged elements to be exposed.

scraped down fully (and carefully) before and after use with a palette knife and then covered with plastic for storage. Never clean a leather roller with solvent.

- Remove ink from the can by skimming the surface with a stiff metal spatula. Do not gouge into the ink as this can leave uneven crusts.
- Work the ink onto the inking slab with a palette knife or spatula.
- When the ink feels pliable, spread a 2 cm (1 in.) wide strip across the slab and roll it until both the slab and the roller look like velvet.
- Sponge the inking slab with clean water and keep the surface of the stone or plate (particularly the edges) damp but not too wet. The application of water is necessary to protect the sections without imagery from accepting ink.
- Roll the ink onto the surface. Change directions four times. Recharge the roller with ink and sponge the surface each time.
- When surface is ready for printing, the inked areas should be prominent.
- Place the paper onto the surface of the plate or block.
- Cover it with newsprint paper. Add padding if necessary depending on press.
- Cover it with the tympan and run it through the press.
- Repeat the inking and dampening process if further prints are required.

The characteristic qualities of this medium are more painterly and autographic than other print techniques.

Some examples of lithographic printing are shown on the following pages.

In *Salt de Pitx* the artist has used two colours; black and silver. The black is a lithograph which was hand-drawn/painted directly onto the zinc plate, processed and printed using a litho press onto Somerset Satin Soft White 300 gsm paper.

◀ Danielle Creenaune, *Salt de Pitx*, 2004, 56 × 76 cm (22 × 30 in.). The artist used the Artichoke Workshop in London to produce this monoprint which has reference to, but is not part of, an editioned series.

The print was left to dry completely (at least one week). The surface image was produced as a monotype using silver oil-based etching ink, diluted with a little white spirit and painted directly onto a thin sheet of Perspex™ by tracing the original image from the litho plate. It was then transferred with a marker pen onto the reverse of the Perspex™ for registration purposes. The paper with the black litho image was first soaked for about 5 minutes (to make it more receptive to additional ink) and then blotted. Finally, the silver image on Perspex™ was transferred to the original black litho print using an etching press.

Another way of working is to use one basic template and develop ideas through the working process. In doing this, an artist can experiment with the original theme from which a body of work can evolve by taking the initial idea to various conclusions with exciting results.

David Jarvis produces lithographic monoprints using the same stone as a starting point, which is an excellent beginning for making a series of monoprints. In *Salix II*, he used litho crayons and some tusche on a litho stone to enhance the grain and create texture. This monoprint has been worked on extensively. Jarvis used many print runs. He used a stencil cut out of card and printed this using the relief method. He printed with transparent ink and finally dusted the image with pearl lustre. Pearl lustre is a powder obtained from theatrical suppliers. It can be applied with cotton wool or a soft cloth, and adheres to undried oil-based ink after the final stages of printing and adds an attractive sheen. Water-based ink is not suitable, as the dust would not adhere.

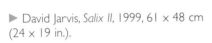

► David Jarvis, *Salix II*, 1999, 61 × 48 cm (24 × 19 in.).

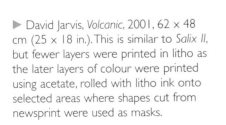

► David Jarvis, *Volcanic*, 2001, 62 × 48 cm (25 × 18 in.). This is similar to *Salix II*, but fewer layers were printed in litho as the later layers of colour were printed using acetate, rolled with litho ink onto selected areas where shapes cut from newsprint were used as masks.

 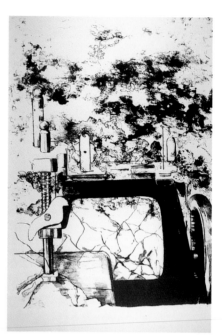

▲ Jackie Newell, *Industrial Landscape 1 and 2*, 1998, 22 × 30 cm (9 × 12 in.). These are 3-colour zinc plate lithographs using a direct litho press (these presses are useful because they accommodate both stones and plates). In this series, extra copies were deliberately printed to serve as two individual monoprints, taken from various stages of the editioned print-run.

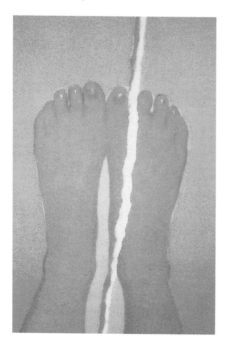

◀ Alan Cox, *Two Square Feet*, 2003, 60 × 60 cm (24 × 24 in.). This is a photo-lithographic monoprint. The artist took the photograph himself, which was then processed onto a photographic aluminium plate by Graphic Techniques, London. He then printed the first image with a dark mauve ink using a flat-bed offset press. The next colour, a soft yellow cream, was top rolled onto an acrylic sheet and printed over the original on a direct lithographic press.

▶ Murray Zimiles, *To Die with Honor, Wounded Fighter*, 1996, 55 × 75 cm (22 × 30 in.).

▶ Murray Zimiles, *Loss*, 1997, 55 × 75 cm (22 × 30 in.). The artist has used the same technique as in *To Die with Honor, Wounded Fighter*, but in this print the image of the medieval city was painted directly onto the surface of the lithograph, which is the unique element in this print. This image describes a literal before and after scene of Europe in the Second World War

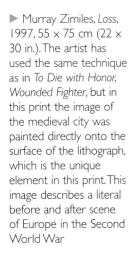

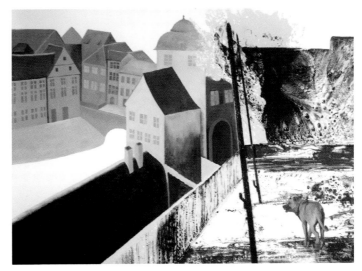

The American artist, Murray Zimiles has produced some powerful mono-prints using lithography as a medium to express stories of political and historical importance. In *To Die with Honor, Wounded Fighter*, the artist has drawn by hand the black and white part of the image on a lithographic plate using toner, litho crayon and tusche, and printed it in two colours: opaque black and 95% transparent black (95% transparent base and 5% opaque black). The colour element of the image was printed on a separate sheet and painted with acrylic. It was then cut out and collaged onto the original lithograph.

The story behind this image is that when the Warsaw ghetto was all but exterminated, a heroic group of young Jewish fighters decided to rise up against the Nazis by buying, stealing and manufacturing weapons of various types. *To Die with Honor* was scrawled on the ghetto walls as an attempt to inspire and recruit others to fight.

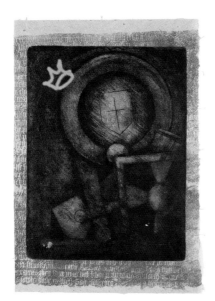 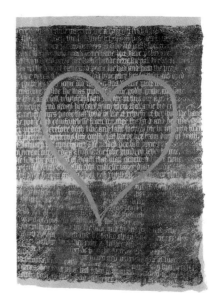

Combination printing

Printmaking offers an incredible variety of opportunities to practising artists, as they can learn to produce images using its media, and incorporate many methods or processes within the same print. This offers the opportunity to utilise the character of each medium and create a balance and visual harmony in their integration, which can be particularly significant in the production of monoprints, where prints can be modified and themes explored in individual works.

In *Passages of Times*, the artist began with etchings on 16 gauge copper, using soft-ground and aquatint. Two of these plates were heavily bitten in ferric chloride and printed using 95% black and 5% transparent base ink. Following this, lithographic transfer paper was used to take a rubbing of a 13th century epitaph from a church in Devizes, Wiltshire. This medium was chosen because it is both convenient and portable. Transfer paper has two surfaces; the artist carefully peeled the top away to reveal a very fine layer akin to a onion skin which made it super-sensitive and suitable for this process. She then placed and fixed it carefully over the area for rubbing and used a litho crayon to transfer the image. This transfer paper was then processed onto a zinc lithographic plate and printed on a litho press over the etched image. The litho ink used was transparent base only, followed by an application of graphite dust directly onto the wet ink of the print. The final stage was to screenprint the heart and graffiti in oil-based screen ink. The reason for using the dust was to suggest erosion and decay.

◄ ◄ ◄ Jackie Newell, *Passages of Times*, 1995, 75 × 55 cm (30 × 22 in.). This is also a combination print, incorporating litho, etching and screenprinting. Realising the complexity of the techniques and imagery involved, the artist chose at the beginning to create a single print of each image to complete the triptych.

► Dee Whittington, *Metropolitan Pyrotechnics*, 1997, 15 × 12 cm (6 × 5 in.) from the *Cathedrals of the City* suite. This is a combination print, using the techniques of lithography, screenprinting and torn, hand-printed Japanese paper, the latter being collaged to complete the image. The main background is a lithograph on thin Japanese paper, which was printed using a large offset flat bed litho press. Presses such as these are sometimes available in well equipped workshops and art schools. Although in this instance the print is of a modest size, the advantage of these presses is that they can accommodate outsized sheets of paper and are therefore suitable for posters and big art prints.

7 ▪ COLLAGE PRINTS: MIX AND MATCH

Collage is a fun, extremely creative and expressive process for artists at all levels. Simple collage techniques can be applied by hand and when used in small areas can transform an image. More sophisticated techniques require a press.

The introduction of collage by the Cubists in the early 20th century opened up a vast potential for inventive solutions. The inclusion of materials other than paper was made possible; such alternative materials could include virtually anything.

A press is not always required when making collage monoprints. Anne Marie Foster, who works in a small studio with limited facilities, produces prints by hand burnishing and favours the ecological use of materials. She recycles whatever is available in her workplace.

Collage is a principal element in the work of Tara Sabharwal owing to its flexibility and the opportunities it presents for layering. This offers endless,

▲ Diane Miller, *Yellow Falls*, 62 × 47 cm (25 × 19 in.). This print utilises collage combined with a monotype.

▲ Anne Marie Foster, *Skin – Composite 1*, 1991, 75 × 70 cm (30 × 28 in.). The artist used mixed media with added colour and texture, both sourced from glossy magazines. She printed 12 individual monotypes with collage, which she presented in a grid format mounted on rough, heavyweight, handmade paper to form the composite work.

ongoing possibilities as it is
not solely dependent on
printmaking processes and
encourages freedom of
expression.

Bottles in a Row and
Dreamworld were made by
the following method:

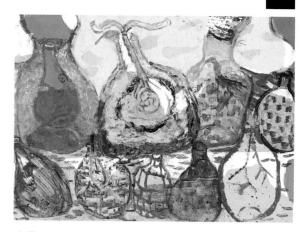

▲ Tara Sabharwal, *Bottles in a Row* and
▼ *Dreamworld* 2002, 45 × 65 cm (18 × 26 in.).

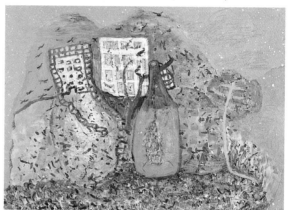

- The printing paper was
 selected and soaked. The
 timing of this depends on the
 paper brand and the amount
 of sizing. (Size is the
 glutinous material made of
 flour, varnish, glue or resin
 that is used to fill the pores of
 paper. Paper with little or no
 sizing, such as German Etch
 or Manyani, does not require
 soaking for more than 5
 minutes, in fact a light
 spraying of water is often
 sufficient, unlike a more
 heavily sized paper, such as
 Somerset, Arches or BFK
 which require at least 30
 minutes soaking.)
- The pressure of the press was
 adjusted to accommodate the block (see Chapter 2).
- The selected ink was rolled onto the surface of the Perspex™/Plexigraph™
 block, which had been loosened with thick linseed oil. This mixture was
 drawn into with cotton buds. The unwanted ink was removed with paper
 towels, fingers, etc.
- Turpentine, spirits and lighter fuel were also applied by sprinkling and
 spraying to loosen areas of ink and create textures.
- Fragments of coloured Japanese, Indian and Thai papers were placed under
 the prepared block to arrange a suitable composition.
- The pieces were then brushed with a thin coat of methyl cellulose (wall-
 paper paste) mixed with water and covered by the pre-dampened printing
 paper (blotted). This latter paper was placed directly over the inked block.
- This was backed with clean newsprint and blankets and then run through
 the press.
- The printing paper was lifted carefully from the block to ensure all fragments
 were stuck to the printed image.

Tara Sabharwal sometimes includes stencils in her work by cutting forms from acrylic or Mylar sheets, which are inked and added to the prepared block, creating positive shapes (areas that will print) and/or negative features (areas that will resist ink and not print). Sometimes this may include the addition of watercolours and gouache, applied by hand to enhance the final image. Tara has proved that this technique produces colourful prints that are both dynamic and playful.

The versatility of collage is useful in the creation of monoprints. It can be incorporated in the printing process to create one print, or it can be used as an ongoing process that can individually adapt what would otherwise become a limited edition print.

Pre-printed material is commonly used by artists as an opportunity to investigate texture and imagery. This material can include the recycling of all old printed matter, such as magazines, newspapers, promotional literature, old letters, etc.

▼ Dee Whittington, *High Renaissance High Revs*, prints *II* and *IV*, 2003, 75 × 55 cm (30 × 22 in.). In these two monoprints, the image has been manipulated by the use of collage to fully investigate a basic theme. The medium used was photographic screenprinting and the composition was originally created from the use of digital imagery. Collage was applied during and after the printing process.

▲ Jackie Newell, *Carte Musée* (left) and *Le Louvre*. These are both monoprints created during a workshop demonstration given to students. They are a result of an art college trip to Paris. The artist included all the tourist ephemera such as tickets, fliers, maps, torn pamphlets, etc. to recreate the ambience of a retrospective show by Kurt Schwitters.

Some artists have selected old textbooks as a base for their imagery. This is due to the content and often superb quality of paper, which can be sensitive and receptive to various printing media.

Keeping a journal is another useful means of expression that enables an artist to collect and record information in a personal way. Joseph A Osina has been maintaining his journal from 1991 to the present and it is an ongoing project. It contains his monotypes on Japanese paper which he then collages onto his own handmade paper (cotton/abaca).

The simple and effective method of collage experimentation with various materials aids the development of themes and images. It is a quick solution to many aspects of printing and can save or revamp a 'lost' print, create focal points when used with sensitivity and add emphasis where required. It adds an immediate and exciting dimension to the process of theme development, perhaps because of the variety of materials which can be employed. Such materials can include fabrics, thin plastics, natural objects such as leaves or feathers and artwork produced previously.

PAGES 98-99: Greetings cards can be produced by using elements of existing prints. These examples were made by Tor Hildyard, Sue Conti, Jackie Newell and Dee Whittington. Making cards can be a resourceful method of utilising available materials and can include many aspects of printing such as woodblock, etching, litho and screen, etc.

◀ Dee Whittington, *Banker's Draft*, 2003, 45 × 37 cm (18 × 15 in.). Here the artist has produced a study by assembling digital imagery, screenprints, hand-drawings, parts of collaged musical scores and tracing paper (the latter used for its transparent effect). By bringing together the different elements one can explore the many possibilities for producing a final result, which can be a unique work in itself, or a starting point for an edition.

◀ Vikki Slowe, *Variation Two*, 1998, 31 × 28.5 cm (12 × 11 in.). Here the artist has constructed an area of silver and gold foil fixed to a cardboard base. This area has then been collaged onto the surface of a conventional hand-coloured etching which makes the work subtly three-dimensional. This graphic, linear print is an imaginative adaptation of one image, where the depth gives an interesting addition to the convention of a two dimensional print.

▶ Paula Henihan, *Peripheral Consciousness*, 2003. Both prints: 105 × 24 cm (42 × 9 in.). The artist produced a unique concertina book from an old, hardback volume on botany. The finished artwork has the intimacy of a book whilst retaining the beauty of an original fine art object.

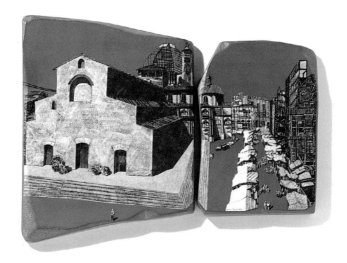

▲ Anne Desmet, *Florence Market*, 14 × 19 × 0.9 cm (5 × 7 × ½ in.). In this work, assorted details from various wood engravings (and lino blocks) were printed in black oil-based inks onto a variety of Japanese papers. To create the final image the artist has constructed details of relief prints collaged onto an MDF panel which was previously prepared by painting with several layers of plaka (a casein-based paint). It was finished by hand with the addition of direct drawing in black pen, pencil and coloured pencil. The final work creates a substantial and striking architectural study.

◀▼Anne Gilman, *Contra el mal de ojo* (*Against the evil eye*), 2002, 23 × 15 cm (9 × 6 in.). This book contains mixed media and digital work with hand drawing.

▶ Joseph A. Osina,
*Gestures &
Fragments,*
21 × 16 × 4 cm
(8½ × 6½ × 1¼ in.).

▼ Murray Zimiles, *Scavenger,* 1997, 75 × 55 cm (30 × 22 in.). The artist has combined two prints into one, by painting over one print in acrylic paint which was then cut and collaged to the surface of another printed image. This is an interesting development because it explores the potential of printmaking and painting to create the unique image. In this instance, collage becomes much more than the addition of various textures and papers because it allows much greater freedom of expression and imagery to be introduced into printmaking. The print is part of the artist's Holocaust series, and depicts a scene of abandoned, wild dogs scavenging across Europe during the Second World War, representing the universal devastation found after any war.

8 ▪ NEW MOVEMENTS: INNOVATIVE AND DIGITAL

Innovative techniques

Art traditions in the past have been eroded by the *avant-garde*, thereby creating the development of new movements in art history. Provocative, dynamic work is often outside the accepted boundaries of convention, but is exciting to witness and produce. Monoprinting offers an opportunity to use and incorporate unusual materials and processes to add resonance and sparkle to the traditional printmaking techniques.

The African American artist Willie Cole has chosen an everyday object, the iron, to produce powerful and symbolic works as in *Domestic ID IV*. Cole's work embraces the essence of his African roots and his scorcheded imprints are reminiscent of tribal masks. His unusual technique is achieved by heating the iron to a high temperature and then applying intense pressure to various surfaces. Cole likes the physical process of branding and the element of surprise produced by the imprint. His choice of matrix stems from his childhood in New Jersey, USA, where he lived with his grandmother and great-grandmothers who worked as housekeepers and often requested that he should repair their irons. These domestic items used as metaphors became valuable tools and resources to Cole, and he took at least 15 with him into his first studio in 1980.

Unusual, innovative developments in the application of alternative materials have created different platforms from which artists can work. The

monoprint techniques employed in the series *Epidemic Landscape* by New York artist David Hamill combine the traditional use of stencils and woodblock stamping on surfaces, which later have been treated with unusual materials to create a unique finish.

His work reveals marks that remain from ripped stitching and torn elements. He used thick blotter paper, treated with tar made to resemble animal hides, which he

◀ Willie Cole, *Domestic ID IV*, 1992, 85 × 80 × 5 cm (34 × 32 × 2 in.). Scorches and pencil on paper in window frame.

▲ David Hamill, *Epidemic Landscape*, 1992, 240 × 450 cm (96 × 180 in.).

stitched together to create a 'quilt'. This was later ripped, abraded, generally mistreated and hung from the wall like a tapestry. The sense of decay in this entire series reinforces the notion of a body ravaged by disease, as these images were born out of symbolism referring to the days of the Black Death, the bestiaries of the Middle Ages and the current AIDS epidemic. Hamill's controversial subject is well illustrated by his perceptive and sensitive selection of unusual media.

Another unusual choice of material and process is made by Roy Willingham in *Rockface City and Ravine* and *City of Rocks and Bones*. The process consists of hand-printing from end-grain woodblock onto polymer clay, which was oven fired. The fired clay was then cut and collaged onto 1500 micron conservation mountboard, hand-coloured with Plaka paint and distressed using sandpaper, burnisher and cloth during hand-colouring.

▲ David Hamill, *Y*, 1992, 180 × 270 cm (72 × 108 in.). Mixed media on paper.

▲ David Hamill, *Blanket* (detail), 1992. Oil and removed stitch on paper.

▲ Roy Willingham, *Rockface City and Ravine* (left) and *City of Rocks and Bones*, 2000, 13 × 4 cm (5 × 2 in.).

▶ Kikis Alamo and Jose Ramon Alejandre, *Doino* series, 2002, 35 × 27 cm (14 × 11 in.).

The final artworks are reminiscent of archaeological sites and landscapes.

Diversity of material plays a major role in creating innovative prints. Alexia Tala, a Chilean artist, also works in an unusual medium that she has developed through years of working with wax and pigments. The equipment required for her process is quite basic: a hot box with light bulbs of 100 kw on top of which is placed a plate of anodised aluminium. The artist uses this as a base to draw and collage, using encaustic sticks of paraffin and beeswax. These are melted and mixed with resin and pigment and then transferred onto paper, creating a richly textured result. This method is similar to that used in monotypes (see Chapter 2) as the image is drawn directly onto a surface without a pre-formed matrix and is therefore individual.

Kikis Alamo and Jose Ramon Alejandre are both Mexican-born artists who currently reside in Spain,

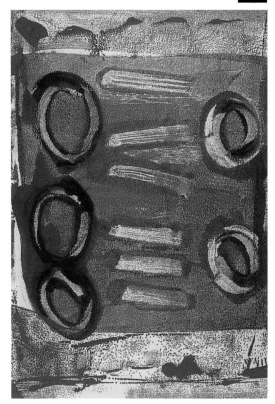

▲ Alexia Tala, *Untitled*, 45 × 37 cm (18 × 15 in.).

▼ A selection of Paperki fine art papers.

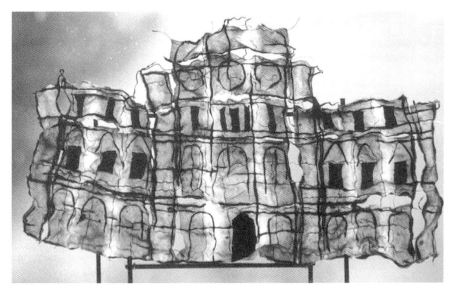

▲ Kikis Alamo and Jose Ramon Alejandre, *Ajuria Enea*, 2002, 24 × 18 cm (9 × 7 in.). This image shows how work can be constructed using papermaking to create exciting results. This self-standing image is a linen paper sculpture, evocative of architecture and decay in ancient cities. The construction stands on wooden sticks, which are covered with black handmade paper. The artists created three monoprints in this series, using a similar style.

▲ Joseph A. Osina, *Alphabet Mountain*, 1991, 34 × 58 cm (13.5 × 23 in.). This monotype was printed on Japanese paper, which the artist sent to Paris to be mounted by a fan expert. It was then returned to him in New York, and was completed with the addition of copper leaves fixed to the front and back covers of the fan. The artwork was exhibited in a show of contemporary fans in Paris.

where they have established the company Paperki. Their workshop produces beautiful handmade paper and fine art prints. Their style of work is highly personal and its process begins with making a piece of white cotton paper, which they do not allow to dry. Another piece of paper is made from refined abaca or linen fibres, the pulp of which is coloured in a vat which is then stamped as an image onto the previous wet, white paper and allowed to dry. The artists never use glue or ink in the production of their work and the finished result has a transparency that utilises light as an integral part of its aesthetic design.

Artists' studios and workshops can offer the opportunity to explore possibilities to experiment with a wide variety of techniques and materials. This is particularly the case in monoprinting where freedom of artistic activity is often a lure to the making of an original print.

The opportunity of combining different media and styles is employed by the artist Sandy Sykes, who displays enormous energy in her work and utilises many media and contrasting materials. Her work from the *Hedgehog* series was inspired by passages from the book *Possession* by A S Byatt. Sandy Sykes' two works *Sometimes it Rains* and *So do I* are multi-printed monoprints, which have been run through the press numerous times, using many layers of transparent base, as well as opaque colours applied to selected areas. Various processes have also been used, including etching, wood, linocuts, flexiplate, *chine collé*, plastic stencil, tracing paper, special tissues and silk thread.

▲ Sandy Sykes, *Sometimes it Rains* (left) and *So do I* (right), 2000-2002. Both prints: 77 × 58 cm (31 × 23 in.).

◀ A demonstration print by Jackie Newell on fine canvas, printed without a press from black ink rolled onto Polyfilla™ on MDF board. It was later secured to a free-standing armature to make a unique work. The Polyfilla™ can create wonderful textures, but as a block it is not durable because the plaster crumbles under pressure and disintegrates when damp.

◀ Steve Mumberson, *Bride & Groom*, life size (detail above). The artist has stretched tissue over a plastic armature and on to this structure he has collaged various elements of his printed images.

Crimping shears have been used to cut plastic and stencil shapes, which were tied into place by use of functional stitches, leaving arbitrary silk marks evoking the art of Victorian stitching and sewing.

Innovative monoprinting offers opportunities to explore new methods of working. The boundaries of printmaking can be extended beyond two dimensions into areas of three-dimensional installation. Artists can make constructions from their own printed material, which need not necessarily be from paper, but could be fabric, plastic and clay.

▶ Steve Mumberson, *Aeroplane and Camera.*

▼ Margarida Palma Martins Costa, *Daemon 1* and *Daemon 4*, 2004, 19 × 9 × 5 cm (7 × 4 × 2 in.).

The concept of moving printmaking away from its conventional two-dimensional status provides many exciting and functional possibilities. Another artist who produces three-dimensional monoprinting is Steve Mumberson, who is a multimedia artist using printmaking in a unique and interesting manner. His work employs many materials and experimental possibilities, which are often constructed out of his own prints.

A further development on three-dimensional scale is the production of a series of unique objects exploring a theme connected with dolls. These are by

the artist Margarida Palma Martins Costa, who pursues in her *Daemon* series a form of self-portrait. She has produced many works based on a fabric doll she originally made as a child.

She started these works by screenprinting the images on canvas and other fabrics, (see Chapter 5) before using them to construct the final objects. They are stuffed with different materials, such as hemp or cotton. No two dolls are alike, although the process is similar in all of them and each has been modified in its production.

Digital techniques

Digital techniques have found a special role in printmaking. They include the production of computer generated images, which can range from the simple use of a home PCs drawing toolbar, through to achieving professional results using industry standard software such as Adobe Photoshop™, or producing images using digital cameras. This section examines how computer generated work can be developed, by the addition of other media and techniques, to produce monoprints.

It is very useful for artists to understand digital techniques, not only for the aesthetic production of artwork but also for the practical benefits offered, such as transmitting images via email, or placing them onto websites. Digital work also produces wonderful, fast and expressive results to make or include in monoprints.

Many towns have digital studios where artists can acquire the necessary basic knowledge and proceed to gain experience in this technology. These studios can be attended during open access periods, specific classes, or one-to-one tuition.

▲ Cecile Garcia, *Pour Me*, 2004, 42 × 30 cm (17 × 12 in.).

▲ Jen Boakes, *Construction Sunset*, 2003, 21 × 30 cm (8 × 12 in.).

Cecile Garcia is an artist and computer graphics tutor, who is interested in creating intriguing surfaces and textures inspired by retro patterns, illustrations and design from the 1950s and 1960s. In *Pour Me* she has used fine liner pens, a white gel pen, silver and white pencils, and these were worked into a digitally manipulated image printed from Adobe Photoshop™.

Resourceful artists have proved that ordinary domestic and household materials can be incorporated into the digital printing process to produce unusual and exciting results. PVA glue was the substance selected by art student Jen Boakes for the base of her digital image *Construction Sunset*. The unusual process she used is as follows:

- The image was drawn and manipulated using Adobe Photoshop™.
- It was printed onto acetate using a laser printer.
- The ink remained wet on this shiny surface.
- The artist then lifted the acetate and placed it on a flat, rigid surface.
- PVA™ glue was poured carefully over the entire image in a thin layer.
- The acetate with glue was dried over night.
- This drying process caused the glue to lift the wet ink from the acetate in a unique and irregular manner and it sealed the image in a semi-translucent background.
- The result, unlike conventional work on paper, dried to a smooth, shiny, tactile finish, which benefits from back-lighting on presentation.

Household bleach diluted with water can alter the properties of toner used in inkjet printers when applied to the surface of the printed paper. Such an

◀ Huy Nguyen, *Rude Boy*, 2003, 21 × 30 cm (8 × 12 in.).

application process was used by Chinese art student, Huy Nguyen, in his print *Rude Boy*. This image is based on a set of photographs taken by the artist on the London underground, which were scanned in Adobe Photoshop™. He experimented and altered the image before printing it onto tracing paper, which was his own inventive and original choice. Finally, graffiti was applied to the print by hand, using a fine brush dipped in diluted household bleach, lifting the ink from the desired areas to complete his scene of urban life in the city.

Digital art is generally an expensive area in which to work, not only due to the initial outlay for basic equipment, i.e. a P.C., printer and software, but also the ongoing cost of toner and specialist papers. However, a variety of materials are sold at varying prices and it is sometimes tempting to select a paper that is not recommended by the manufacturer as the ideal choice.

Such a choice for cheaper paper was made for reasons of economy by the art student Simon Fitzgerald. He scanned into Adobe Photoshop™ his own drawing study of *Cathedral* by Auguste Rodin, and then printed it using an economy photo satin paper on an Epson inkjet printer. The result was not intended, and the outcome was originally unsuccessful, as the image was reduced to a pixelated dot tone of wet ink. However, being a resourceful student, he quickly blotted the wet print onto printmaking paper, producing a mirror image. This meant, of course, that he had two images from which to work.

The former image, printed on the shiny satin paper, was then blotted to reveal subtle dot tones of green and pink, reminiscent of Georges Seurat and Pointillism. This prompted Fitzgerald to add further isolated areas of colour in dot tone, using acrylic paint. The result was a happy accident, which is a frequent (and fortunate) occurrence in printmaking.

American artist Anne Gilman refers to the New York City subway map in her work entitled *Dress Form*. Her print has been digitally manipulated into an hour-glass shape. Several prints were made, but each digital print was different.

▲ Simon Fitzgerald, *Rodin's Cathedral*, 2004, 21 × 30 cm (8 × 12 in.).

▲ (right) Simon Fitzgerald, *Rodin's Cathedral II*, 2004, 21 × 30 cm (8 × 12 in.).

▶ Anne Gilman, *Dress Form*, 2000, 21 × 30 cm (8 × 12 in.).

The artist made two or three versions which are unique due to the addition of hand-colouring, in this case the dress form, which evokes a personal reference to the artist.

London based artist Zara Matthews uses the concept of the human head in most of her work. In *Screen* the images are manipulated using Adobe Photoshop™ from a photographic self-portrait. The entire *Screen* series is a box set of 23 monoprints. They are all digital

◀ Zara Matthews, *Screen*, 2000, 27 × 21 cm (11 × 8 in.).

ink-jet prints on Somerset paper. Zara is an artist who works in multimedia, and in her printmaking she prefers to print only unique works.

Building imagery using digital technology offers fantastic scope to explore and re-evaluate the well-known. Worldwide, familiar icons can be 'digitally processed for reassessment' using the wide array of computer graphic software available. In Dee Whittington's *High Pop* the artist combined imagery from

Wurlitzer juke boxes with church designs by the 15th century Italian architect Donato Bramante. The digital element was printed onto an A4 acetate sheet and relevant areas were then cut out or drawn upon, using Rotring pen and ink. This item was finally placed and fixed onto hand-made thick coloured paper and various fine Japanese papers. Dee Whittington suggests her working style could be called 'imagist'. This describes the idea of creating unlikely alliances in pictorial form by building and adapting formal design, to create an assortment of improbable juxtapositions as part of the final compositional statement.

◀ Dee Whittington, *High Pop*, 1992, 20 × 25 cm (8 × 10 in.).

▲ Carmen Lizardo, *Self Portrait with Circles*, 2002, 50 × 100 cm (20 × 40 in.). The artist has again added wax and oil paint to her work on canvas.

▼ Carmen Lizardo, *Self Portrait with Arrows*, 2002, 70 × 75 cm (28 × 30 in.). This image was printed onto canvas and later oil paint, charcoal and wax were added.

▲ Murray Zimiles, *Buffalo Dance*, 2003, 55 × 50 cm (22 × 20 in.).

Contemporary technology brings convenience to working methods. The latest laptop/wireless-free computers with Internet links, digital photography and easily transportable printers encourage an easy-to-work-anywhere attitude. On a recent trip to Florence, Dee Whittington took digital photographs from her apartment window of neighbouring tiled rooftops, which were immediately printed onto glossy photo quality paper using a lightweight transportable printer. The resulting print was drawn onto with Rotring pen and ink. It was finally torn or distressed in specific surface areas, prior to adding digitally manipulated and printed acetate to create the completed study, *A Night on the Tiles* (see page 2).

The American artist Murray Zimiles produced his work *Buffalo Dance* using a professional high quality, large format, digital printer (the Epson 7000). High quality machines like this are expensive and not necessarily owned by all artists who work digitally. This service can be accessed at local design bureaux who offer this printing facility (it is worth noting that this process could be costly).

Zimiles' digital print was made by combining a number of images from a variety of scanned in material, such as pictures and textures. Both the distortion and overlays were created by scale manipulations and filters using Adobe Photoshop™. The final print was hand-coloured using watercolour pencils and pastels. The monoprint represents the artist's interest in the wild animals that are icons of the vanishing American west.

Digital work does not have to be produced using ordinary printing paper or the modern photographic glossy/matt papers. It can be printed on age-old conventional materials like canvas or linen, a procedure which adds traditional authenticity to finished artwork.

Mumberson's working technique used to produce *Queue* was as follows:

- He began with photographs as a starting point from which to work; he then made several copies of these photographs to repeat the image.
- He painted, collaged and drew over the photographs using them as a base.
- He scanned these amended photographs into Adobe Photoshop™, using a system of layers to combine imagery.
- He used the drawing tools of Photoshop™ to take the image further.
- He adjusted the formatted images prior to printing using a large format Epson printer.
- To achieve the proper colour balance (colour management) he tested the prints. When he was satisfied with the colour he printed two images onto canvas, the first being smaller than the second printing.
- He always allowed at least 24 hours for the prints to dry.
- Finally, he treated his prints with a conservation spray varnish. This helps to protect the prints against damp.

This artist chooses to produce only monoprints, one in each size. This is due not only to the high cost of printing such work, but is attributable to his experimental, multimedia working style.

Digital techniques provide a great opportunity for artists to explore both new and existing ideas, coupled with the advantage of accessibility, these techniques have become an extremely useful tool to aid the creative process.

▶ Steve Mumberson, *Queue*, 2003, 23 × 33 cm (9 × 13 in.). Print on canvas. The artist used a large format Epson printer at London Print Studio.

GLOSSARY

À la poupée Process of applying more than one colour to an intaglio plate using tightly rolled pieces of felt blanket as dabbers.

Acetate A sheet of clear plastic, used for registration purposes and also for wrapping finished mounted prints.

Acetone A screenprinting solvent.

Aquatint An intaglio method of using fused dots of resin onto a metal plate, which act as a resist to acid in order to create a washy, tonal effect.

Baren Traditionally a Japanese hand burnishing tool covered in bamboo sheaf, used to burnish relief prints.

Baumé hydrometer An instrument used to measure the strength of acid.

Bevel A slant filed to the edges of an intaglio plate.

Biting Corrosive effect of acid on an exposed metal plate.

Bleed print An image that extends to the edge, or beyond, the paper.

Brayer A small hand roller used to spread ink over plates and blocks.

Burin A type of engraving tool used on wood or metal.

Burnisher Smooth, metal tool used to smooth and polish rough areas.

Carborundum An abrasive grit, used to create tonal areas on plates, or to grain litho stones.

Chine collé A method of adhering thin pieces of Japanese paper to the larger printing paper at the same time that the inked image is printed.

Collagraph Print made from a collage of various textured materials, adhered to a card or metal base.

Collotype Reproductive printing technique based on gelatine process, to produce a wide tonal range.

Colour profile Used in colour management, profiles describe the colour characteristics of individual devices, enabling correct translation of colour from one device to another.

COSHH Control of Substances Hazardous to Health.

Counterproof Offset from a wet print onto damp paper, made by placing them face-to-face and printing using an etching press.

CYMK Refers to half tone four-colour separation system: cyan, magenta, yellow and keyline (black).

Digital image An image in digital form.

DPI Dots per inch on computer monitors.

Drypoint An intaglio technique, made by scoring directly onto a dry metal surface with a sharp instrument.

Engraving Cutting an image into metal or wood, using gravers, burins, etc.

Etching Intaglio process involving acid to bite an image into a metal plate.

Ferric chloride A corrosive salt mixture, used to etch copper plates.

File format Storage of digital information, i.e. TIFF, JPG formats, etc.

Gesso Plaster of Paris mixed with glue which can be used for creating relief blocks and on collagraphs.

Giclée Fine art ink-jet print.

Glassine Thin, non-absorbent paper used as a slip sheet between proofs for long time storage.

Gouge Relief cutting tool.

Hand-bench A screenprinting press.

Hardware Computer equipment such as PC, monitor, printer and similar additional items.

Hotplate Metal box or table which is used for heating plates for various reasons, including laying grounds, inking, fusing resin, melting Caran D'Ache and wax, etc.

Ink-jet printer Non-contact print device, sprays streams of tiny ink droplets through nozzles.

Intaglio Printing process in which the image to be printed is made by cutting below the surface of a plate to hold ink in the grooves.

Landscape format Where paper width is wider than the depth.

Laser printer Device in which laser beam is used to transfer an electric charge of a pattern of an image onto a drum, which is rolled through pigmented toner, collecting ink toner in the charged areas and passing this to the substrate (paper, etc.) by pressure and heat.

Lift ground Etching process in which an image is drawn onto the plate with a water soluble liquid made from sugar, hot water and Indian ink. The plate is then dried and hard-ground is applied to the entire plate. It is then left in hot water to dissolve the lift ground. This is then usually aquatinted and bitten in order to hold ink in the designated area.

Lino cut Linoleum cut into using a variety of cutting tools, a form of relief printing.

Litho stone A smooth limestone, usually from Bavaria that receives greasy ink for printing lithographs.

Lithography Printing process created by the antipathy of grease and water. Produced on limestones or grained metal plates.

Matrix Plate used for printing, such as wood, lino, metal, etc.

Mesh Monofilament polyester material stretched over frame for screenprinting.

Moiré An interference pattern caused by the dot structure of a halftone clashing with the weave of the mesh.

Monoprint A unique print involving a matrix.

Monotype A unique painterly print.

MSDS Material Safety Data Sheet; an international standardised form which manufacturers are legally obliged to provide containing information about materials and chemicals.

Needle Used in engraving or etching to scratch surface of metal.

Perspex or Plexiglass Translucent plastic sheet which can be used for making drypoints, monotypes and engravings.

Pixel One of the tiny dots that makes up a visual display image.

Planographic Method of printing from a flat surface, as in lithography.

Plate Metal, card, or plastic base on which to print.

Portrait format Where paper width is narrower than its depth.

Rasterisation A software conversion of a vector image into dots.

Reduction method Process of making a multicolour print from one block.

Registration Method for aligning separate printed colours into the intended position for the final print.

RGB The colour system based on light, red, green and blue, used when scanning into computers. This is converted to CMYK for output.

Scanning Method of capturing a picture to create a digital computer file.

Screen The frame and mesh used for holding a stencil.

Scrim/Tarlatan Mesh, cotton fabric used as a wiping cloth for etchings and collagraphs.

Serigraph Screenprint.

Snap distance The distance between the underside of the screen and the printing surface. This expression means only the edge of the squeegee is in contact with the paper.

Software Computer programmes, such as Adobe Photoshop or Quark Xpress.

Solvents Liquid that dissolves substances such as ink, paint or ground.

Squeegee Rubber or plastic blade used to force ink through mesh in screenprinting.

Stopping out varnish Acid resist varnish used to prevent areas of etching plate from biting in acid.

Transfer paper May be used for drawing the image in lithography, which can later be deposited on the surface of the stone or plate under pressure.

Transparent base A colourless substance used to extend ink and increase its translucency.

Tusche Greasy drawing material used in lithography and screenprinting. Also used in etching as an acid resist.

Vacuum press bed A screenpress bed with electric suction to hold paper in place.

Vector An image represented on the computer as a set of geometric entities.

Woodcut Block of wood, that is cut into with gouges and cutting tools for relief printing.

Wood engraving End grain of wood that is generally cut with a scorper and fine tools, and then printed in relief.

SUPPLIERS

Printmaking equipment/materials

Intaglio Printmakers
62 Southwark Bridge Road,
London SE1 0AS
Tel. + 44 (0)20 7928 2633
Fax. + 44(0)20 7928 2711

Falkiners Fine Papers
76 Southampton Row,
London WC1B 4AR
Tel. +44 (0)20 7831 1151
Fax. +44 (0)20 7430 1248
email falkiner@ic24.net

John Purcell Papers
15 Rumsey Road,
London SW9 0TR
Tel. +44 (0)20 7737 5199
Fax. +44 (0)20 7737 6765
email jpp@johnpurcell.net
www.johnpurcell.net

Akua Kolor
www.waterbasedinks.com
Contact: Susan Rostow

Paintworks
99 – 101 Kingsland Road,
London E2 8AG
Tel. +44(0)20 7729 7451
Fax.+44(0)20 7739 0439
email shop@paintworks.biz
www.paintworks.biz

Atlantis Art Supplies
7 – 9 Plumber's Row,
London E1 1EQ
Tel. +44(0)20 7377 8855
email mail@atlantisart.co.uk
www.atlantisart.co.uk

TN Lawrence
208 Portland Road, Hove,
East Sussex BN3 5QT
Tel. +44 (0)1273 260 280

L Cornelissen & Son Ltd
105 Great Russell Street,
London WC1B 3RY
Tel. +44 (0)20 7636 1045

A P Fitzpatrick
142 Cambridge Heath Road, E1 5PJ
Tel. 0207 790 0994

Paperki
Paperki Handmade Papers, Apartado
de Correos 106, 20280 Hondarribia
(Gipuzkoa), Spain
Tel./Fax. +34 943 640 555
email contact@paperki.com

London Graphic Centre
16 – 18 Shelton Street, London,
WC2H 9JL
Tel. +44(0)20 7240 0095

Daler-Rowney Ltd
12 Percy Street, London W1A 2BP
Tel. +44(0)20 7636 8241

Pearl Paint Co Inc
308 Canal Street, New York NY 10013
Tel. +212-431-7932

New York Central Art Supply Inc
62 Third Avenue, New York NY 10003
Tel. +800-242-2408

Premier Art Supplies
43 Gilles Street, Adelaide, Australia
Tel. +618 8212 5922

Presses and studio equipment

Modbury Engineering
Arch 311, Frederick Street, London E8
Tel. +44(0)207 254 9980
Contact: Chris Holladay

Harry F Rochat Ltd
15A Moxon Street, High Barnet, EN5 5TS
Tel. +44(0)20 8449 0023

Ashmount Suppliers (Linoleum)
77 – 79 Garman Road, London N17 0UN
Tel. +44(0)20 808 2158/3294

Fayes Metals Ltd
Unit 4, 37 Colville Road, Acton, London
W3 8BL
Tel. +44(0)20 8993 8883

Smiths Metals Ltd
42 – 56 Tottenham Road, London N1
Tel. +44(0)207 7241 2430

Art Equipment
3 Craven Street, Northampton, NN1 3EZ
Tel. +44(0) 1604 632447

Screenmachinery Int
KG House, Unit 4, Kingsfield Close,
Northampton, NN5 7QS
Tel. +44(0)1604 585880
Fax. +44(0)1604 590633
email info@screenmachinery.co.uk
Contact: Patrick Pace

Charles Brand
45 York Street, Brooklyn, New York
NY 11201 – 1420
Tel. +718-797-1887

Edward C Lions Tools
3646 White Plains Road, Bronx,
New York 10467
Tel. +212-515-5361

Gibbon Colourcentres
25 Deer Park Road, Wimbledon,
London SW19 3UE
Tel. +44(0)20 8540 0304
Fax. +44(0)20 8542 5256

Sericol
www.sericol.com

Folex Ltd
18 – 19 Monkspath Business Park,
Solihull, West Midlands B90 4NY
Tel. +44(0) 121 733 3833
Fax. +44(0) 121 733 3222
www.folex.co.uk

Services

Othens OnLine
Linear House, Peyton Place, Greenwich,
London, SE10 8RS
Tel. +44(0)20 8858 8351
www.othens.co.uk
Contact: tony@othens.co.uk

Sky Editions
33 Charlotte Road,
London EC2A 3PB, UK
Tel. +44(0)207 739 7207
email skyeditions@btinternet.com
Contact: Alan Cox, Director

London Print Studio
425 Harrow Road, London W10 4RE
Tel. +44(0)20 8969 3247
email info@londonprintstudio.org.uk
www.londonprintstudio.org.uk

Manhattan Graphics Centre
481 Washington St, New York, 10013
Tel. + (212) 219-8783

Glasgow Print Studio
22 King Street, Glasgow G1 5QP
Scotland
Tel. +44 (0)141 552 0704
Fax. +44 (0)141 2919
email gallery@gpsart.co.uk

Artichoke Printworkshop
Unit S1 Shakespeare Business Centre,
245a Coldharbour Lane,
London SW9 8RR
Tel. +44(0)20 7924 0600

North Star Studios Ltd
65 Ditchling Road, Brighton,
East Sussex BN1 4SD, UK
Tel. +44(0) 1273 601 041

Brighton Independent Printmaking
Module B1, Enterprise Point,
Melbourne Street, Brighton, East Sussex
Tel. +44(0) 1273 691496
email bip@brightonprintmaking.co.uk

BIBLIOGRAPHY

Books

Adam, Robert and Robertson, Carol *Screenprinting, the complete water-based system* (Thames & Hudson) 2003

Adobe Photoshop 7.0: The Official Training Workbook from Adobe Systems (Adobe Press) 2002

Ayres, Julia *Monotype: Mediums & methods for painterly printmaking* (Watson-Guptill Publications/New York) 1991

Desmet, Anne and Anderson, Jim *Hand-made Prints* (A & C Black London) 2000

Hoskins, Steve *Water-based screenprinting* (A & C Black London) 2001

Lambert, Susan *Prints: Art & Techniques* (V&A Publications) 2001

London Print Studio, *Photographic Screen Printing* (course notes)

Mara, Tim *Screenprinting* (Thames & Hudson) 1979

Petterson, Melvyn and Gale, Colin *The Instant Printmaker, printing methods to try at home and in the studio* (Collins & Brown) 2003

Ross, John, Romano, Clare and Ross, Tim *The Complete Printmaker* (The Free Press) 1972

Stobart, Jane *Printmaking for Beginners* (A & C Black London) 2001

Welden, Dan and Muir, Pauline *Printmaking in the Sun, an artist's guide to making professional quality prints using the solarplate method* (Watson-Guptill Publications) 2003

Whale, George and Barfield, Naren *Digital Printmaking* (A & C Black London) 2001

Miller, Diane, 'Manhattan Transfer on New York's leading Print Workshop' *Printmaking Today* Vol. 8 No. 4, Winter 1999, page 19

Miller, Diane 'Branching out. Collaging with prints & papers' *Printmaking Today* Vol. 9 No. 3, Autumn 2000, page 34

Behrman, Pryle 'Shored Fragments ... Arturo Di Stefano's espousal of tradition to represent the world anew' *Printmaking Today* Vol. 12 No. 4, Winter 2003, page 10

Websites

http://manhattangraphicscenter.org

http://www.fineartgicleeprinters.org/pdfs_fine_art_giclee_printers/fineartgiclee_feedback.htm (for Epson Printers)

http://www.waterbasedinks.com/ (for Akua Kolor)

http://www.wolseyartgallery.org.uk/artists/details (for Dale Devereux Barker)

www.alexanderandbonin.com

www.henry-moore-fdn.co.uk

www.londonprintstudio.org.uk

www.moma.org

www.paperki.com

www.thebritishmuseum.ac.uk

INDEX